MASKS OF MEXICO

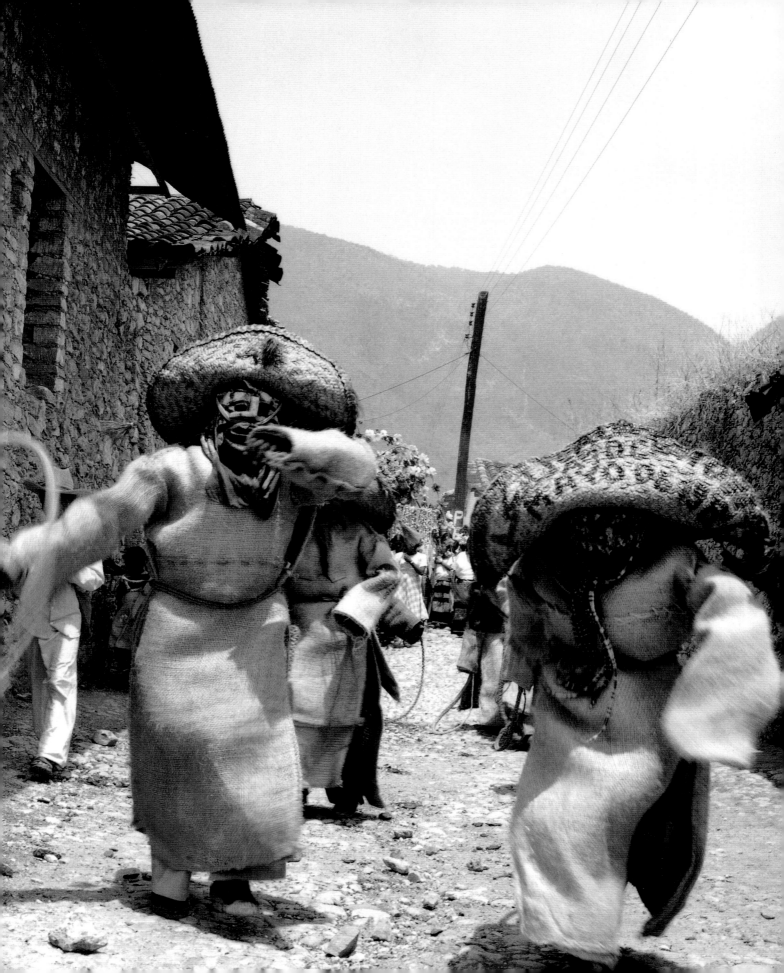

MASKS OF MEXICO

Tigers, Devils, and the Dance of Life

By Barbara Mauldin

Field Photography by Ruth D. Lechuga

Studio Photography by Blair Clark

MUSEUM OF NEW MEXICO PRESS

SANTA FE

Masks reproduced in this publication are from collections
housed in the Museum of International Folk Art, in Santa Fe,
New Mexico. The following abbreviations found in the plate
captions refer to the collections here noted:

IFAF International Folk Art Foundation
MNM Museum of New Mexico

Project Editor: Mary Wachs
Art Director: David Skolkin
Design and Production: Susan Surprise
Typeset in Adobe Centaur, Gill Sans, and Kino
Manufactured in China

10 9 8 7 6 5 4 3 2

Library of Congress Cataloging-in-Publication Data

Mauldin, Barbara, 1949–
 Masks of Mexico : tigers, devils, and the dance of life / by
Barbara Mauldin ; documentary photography by Ruth
Lechuga.
 p. cm.
 Includes bibliographical referencs.
 ISBN 0-89013-329-8. — ISBN 0-89013-325-5. (pbk.)
 1. Indian masks—Mexico. 2. Masks—Mexico.
 3. Festivals—Mexico. 4. Fasts and feasts—Mexico.
 5. Indians of Mexico—Social life and customs.
 6. Mexico—Social life and customs. 7. Mexico—Religious
life and customs. I. Title.
 F1219.3.M4M39 1999
 391.4'34'0972—dc21 98-41771
 CIP

MUSEUM OF NEW MEXICO PRESS
POST OFFICE BOX 2087
SANTA FE, NEW MEXICO 87504

Photograph page ii:
Tlacolero/Tigre drama. Zitlala, Guerrero (Nahua), 1981.

Photograph page vi:
A line of men with painted skin and wearing papier-mâché
masks performs during the Holy Week initiation rites. Jesús
María, Nayarit (Cora), c. 1975.

Contents

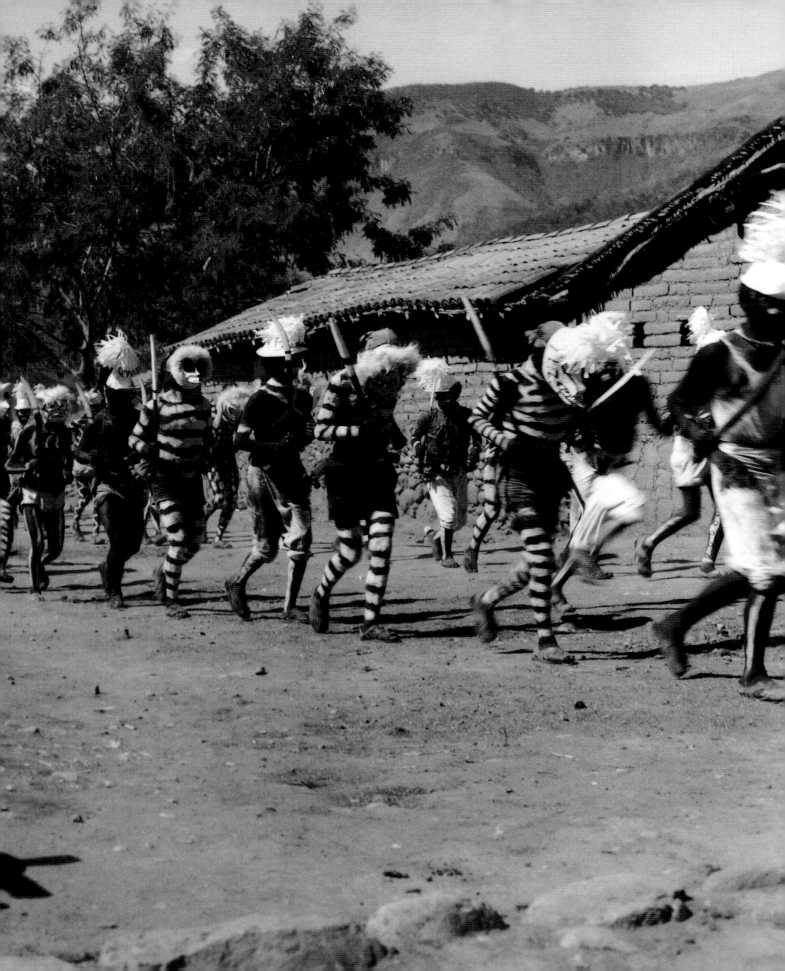

Foreword

The large collection of Mexican masks in the Museum of International Folk Art (MOIFA) has been assembled over the past four decades through the efforts of many people. These include the International Folk Art Foundation (IFAF) Board of Trustees, museum directors, curators, and donors, and several scholars, dealers, and friends. Each of these participants has appreciated the beauty, power, and authenticity of Mexican masks and has devoted his or her time and effort to helping the museum acquire pieces that represent a variety of dance traditions from different ethnic groups and geographical regions of Mexico.

Some of the earliest collecting began in 1956 when MOIFA's Director William Lippincott made a field trip to Michoacán and Jalisco to purchase masks in the villages and gather information on their manufacture and use. A few years later Director William Friedman visited Tabasco and acquired an interesting group of early-twentieth-century masks from that region. In 1970, IFAF supported the purchase of a collection of well-documented Michoacán masks from Enrique Luft, the director of the Museo Regional de Artes Populares, in Pátzcuaro.

IFAF and MOIFA solidified their commitment to assembling a collection of Mexican masks in 1977 when they purchased some two hundred pieces from the Donald and Dorothy Cordry collection. The Cordrys had been conducting fieldwork on Mexican festivals and collecting costumes and masks since the 1930s, and although some of the newer pieces purchased from them for the museum are more decorative than authentic in nature, the collection includes many beautiful examples of well-documented masks from the late nineteenth and early twentieth centuries.

MOIFA's collection received another boost in 1979 when Alexander Girard donated more than 100,000 pieces of folk art to the museum, including 150 masks from Mexico. Although Girard had not himself collected these masks in the villages, he had purchased them from knowledgeable dealers and utilized his own well-developed appreciation of form, color, and folk expression to select the pieces. The result was a significant group of early- to mid-twentieth-century masks that greatly complemented the museum's holdings.

A few years later, in 1983, another generous donation of eighty-six Mexican masks came to the museum from Robert and Kathleen Kaupp. Robert was a student at the University of the Americas in Mexico City in the 1960s and spent much of his spare time traveling to small villages in various parts of Mexico to see dances and purchase masks, many of which were acquired directly from the makers.

As the staff of the Museum of International Folk Art grew in size, a curatorial position was created to oversee the Latin American folk art collection. I was fortunate to be the

first curator to hold this position, and I quickly became fascinated with the Mexican masks. In the spring of 1983 I embarked on a six-week field trip in Mexico to learn more about the festivals and masks firsthand and to acquire additional pieces for the collection. Together with Swiss scholar and collector Valentin Jaquet, I purchased forty-two masks for the museum and met dozens of hardworking mask makers of all ages who were committed to carrying on the tradition of creating masks for local use.

After my appointment as director of the Museum of International Folk Art in 1984, our new curator of Latin American folk art, Marsha Bol, pursued her own research into the fascinating history of Mexican masks. Through grants from the National Endowment for the Humanities, Bol organized the exhibition "Behind the Mask in Mexico," which opened at MOIFA in 1988. In carrying out this project, Bol conducted fieldwork in Mexico with noted Mexican scholars Ruth D. Lechuga and Teresa Pomar, as well as with American scholars Janet Brody Esser and Barney Burns. Brody Esser edited the accompanying book of the same title. The exhibit featured more than thirty costumes and masks purchased for the museum from makers in different regions of Mexico. Video footage was taken of some of the artists at work, as well as of festival preparations and masked dances.

The present curator of Latin American folk art, Barbara Mauldin, has continued the museum's important work in this area. The publication that follows, initiated with the Museum of New Mexico Press, was created to serve as a guide to collectors and a general audience wanting to learn more about identifying Mexican masks by their region and dance type. Mauldin turned to noted scholars, dealers, and collectors, including Ruth Lechuga, René Bustamante, Estela Ogazón, Jaled Muyaes, Barbara and Robin Cleaver, and Jim and Jeanne Pieper, for assistance in gathering information about the mask festivals and to acquire an additional twenty-two pieces to fill some of the gaps in the collection.

Throughout the course of these various projects, individual masks have also been donated by some of the museum's friends and colleagues, such as Stanley Marcus, Rick Dillingham, James Economos, Ruth Lechuga, Teresa Pomar, Barney Burns, Barbara and Robin Cleaver, and Michael Robins.

In the coming decades the Museum of International Folk Art will continue to develop its Mexican mask collection through the support of the International Folk Art Foundation and through donations from patrons such as these. We hope this book will stimulate interest in Mexico's expressive mask tradition and serve to educate travelers and collectors alike.

CHARLENE CERNY
DIRECTOR
MUSEUM OF INTERNATIONAL FOLK ART

Acknowledgments

Although the text in this book is intentionally condensed, a great deal of research went into compiling the information. I am indebted to a number of people who willingly shared their knowledge and guided me along in the process. I especially want to thank Ruth Lechuga, whose publications on Mexican masks are an invaluable resource for learning about masks and masked festivals throughout the various regions of Mexico. Dr. Lechuga kindly committed days of her time to answering questions, taking me to purchase masks from makers and dealers, sorting through hundreds of her photographs of Mexican festivals to help select those for the book, and reading the manuscript for accuracy.

René Bustamante, a Mexican anthropologist who has devoted much of his life to studying and observing Mexican masked festivals, was also extremely generous with his time. He went through the museum's collection and made suggestions for masks to include in the book, answered many questions, and read and commented on the manuscript. Barbara and Robin Cleaver were also very helpful in previewing the collection and in recommending areas in need of additional examples. Jaled Muyaes and Estela Ogazón and Jim and Jeanne Pieper also provided valuable information and spent time going through their slides to contribute context photographs for the book. Gratitude also goes to John Durant, Bryan Stevens, Sam Lemly, Michael Robins, Jim Griffith, John Nunley, Marion Oettinger, Patricia LaFarge, Martha Egan, Peter Cecere, Nelson Foster, Carol Burns, and Jennifer Reil for their information and assistance in this project.

I want to thank as well members of the museum staff, particularly MOIFA's director, Charlene Cerny, who was a key figure in initiating the museum's interest in collecting Mexican masks and answered many questions with her own research in this field. Judith Sellers, MOIFA's librarian, kindly tracked down many obscure reference materials for me, and Paul Smutko, MOIFA's collections curator, helped me reorganize the mask collection and upgrade the storage environment. I am indebted to Blair Clark, photographer for the Museum of New Mexico's exhibitions unit, who produced the beautiful studio photographs of the masks that appear in this book. I am also grateful to Mary Wachs, editorial director, Museum of New Mexico Press, who initiated this project and worked closely with me to bring the book to completion, and to art director David Skolkin and designer Susan Surprise for transforming our ideas into book form.

Much appreciation goes to Laurel Seth, executive director of the International Folk Art Foundation, and to the IFAF Board of Trustees, who generously funded my fieldwork for this project and purchased a good majority of the Mexican masks in our collection. Of course, most of the credit must go to the many artists, both named and unnamed, who produced the variety of masks illustrated in this book, as well as to the people of Mexico who have kept their vibrant festival traditions alive.

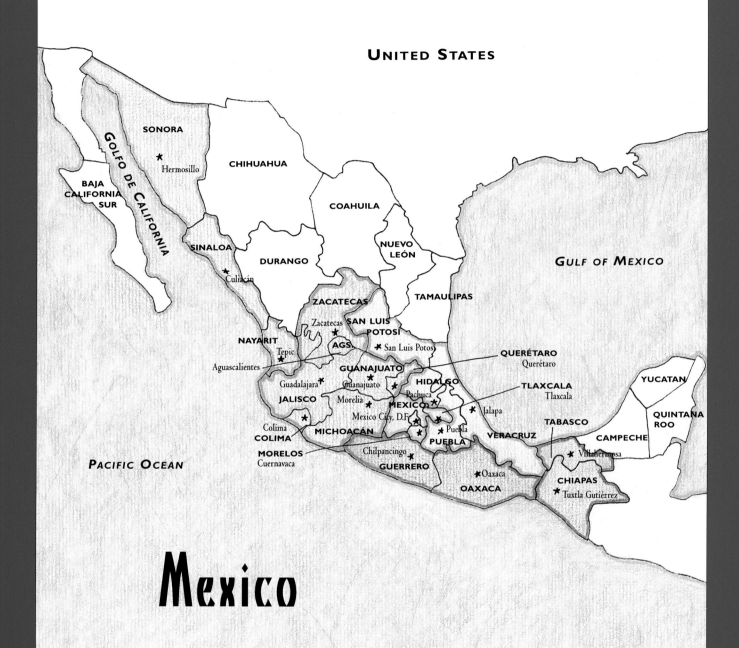

UNITED STATES

SONORA

★
Hermosillo

CHIHUAHUA

BAJA CALIFORNIA SUR

GOLFO DE CALIFORNIA

COAHUILA

SINALOA

★
Culiacán

DURANGO

NUEVO LEÓN

TAMAULIPAS

GULF OF MEXICO

ZACATECAS

★ Zacatecas

SAN LUIS POTOSÍ

NAYARIT

★
Tepic

AGS.

Aguascalientes

★ San Luis Potosí

QUERÉTARO
Querétaro

GUANAJUATO

★ Guanajuato

HIDALGO
Pachuca

TLAXCALA
Tlaxcala

YUCATAN

JALISCO

★ Guadalajara

Morelia

MEXICO

Mexico City, D.F.

★ Jalapa

QUINTANA ROO

★ Colima

Colima
COLIMA

MICHOACÁN

★ Puebla

PUEBLA

VERACRUZ

TABASCO

★ Villahermosa

CAMPECHE

MORELOS
Cuernavaca

Chilpancingo

GUERRERO

★ Oaxaca

CHIAPAS

★ Tuxtla Gutiérrez

OAXACA

PACIFIC OCEAN

Mexico

Regions of Mexico with strong mask traditions.

Introduction

Over the ages, masks have been used as a form of disguise in almost all culture areas of the world. They allow the wearer to become someone other than himself, whether it is for defense, religious purposes, to play a role in a pageant, mock others, or simply to have fun. In a community festival context, masquerade can serve a variety of functions, ranging from trying to understand and control nature and the supernatural, teaching topics such as history or proper behavior, addressing specific problems within the group, or releasing one's own inner tension. This tradition is particularly rich in Mexico, where masked festivals have played an important part in the religious, social, and recreational lives of the people since pre-Hispanic times.

MASKED FESTIVALS IN PRE-HISPANIC MEXICO

Masked pageantry and dancing were important aspects of ceremonial practices in Mexico long before the Spanish invaded this area in the early sixteenth century. Chronicles written by Catholic priests during the first decades of European colonization describe a variety of ethnic groups with highly developed forms of political, social, and religious life, including a range of festivals that took place at specific times during the indigenous groups' calendar year. For the most part, these festivities were intended to honor and entertain the pre-Hispanic deities who, in turn, would bless the people with abundant rain, fertile crops, successful harvests, good health, and general well-being. However, the celebrations also served a social function in bringing the communities together for their own enjoyment. Although specifics of the festivals varied, the main part of the ceremonies involved processions and dancing as well as choreographed theatrical performances. These were usually followed by large public feasts and social entertainment of games, dancing, and comical or satirical dramas.

The chronicles describe a variety of costumes and masks worn during the processions and by the dancers and theatrical performers. These ranged from those used by the high priests to impersonate the deities to the helmet masks of warriors and rulers taking on the identity and power of eagles and jaguars to those worn by performers dressed as birds, insects, and reptiles. Other masks represented old men and women who performed comic acts for the crowds. Satirical dramas involved masquerades that made fun of members of the community or impersonated and ridiculed neighboring ethnic groups.

The larger festivals were generally sponsored by the elite rulers of a region, such as the Aztec, who imposed their political structure and national religion on many ethnic

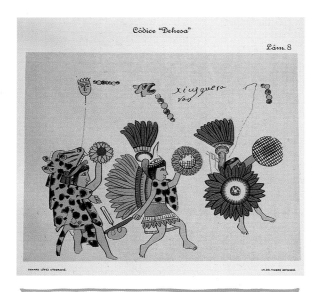

Three pre-Hispanic village chiefs dressed in royal clothing, including a jaguar costume with head covering. Illustration from the *Codex Dehesa*, central Mexico, early sixteenth century. Photograph by Michel Monteaux.

groups in central Mexico during the fifteenth and early sixteenth centuries. Underneath this broad structure, however, most of the population functioned on a level of local kinship groups, which the Aztec called the *calpulli*. This consisted of a community or neighborhood of families bound by a common divine ancestor. The land of the community was defined by the place where the spirit provided his or her special protection, and the religious activity for the *calpulli* was predominantly a celebration of the group's identity as distinguished by its ancestral god. The local festivals followed the structure and activities described above, although on a much smaller scale, with financial sponsorship being rotated from one member of the *calpulli* to another.

MASKED FESTIVALS IN THE SPANISH COLONIAL ERA

After the Spanish conquest of Mexico in 1521, the Europeans dismantled the elite political/religious empires and banned the practice of pre-Hispanic religion. With the collapse of the imperial states, the local kinship communities of the various ethnic groups became autonomous entities and in many instances were incorporated into the Spanish concept of small villages or, when they existed in larger towns, as neighborhoods, or *barrios*. The social and religious functions of these groups were gradually integrated into a Spanish form of social/religious brotherhoods, known as *cofradías*.

European Catholic priests established churches in the villages and *barrios* and assigned Catholic saints to be their patrons. Over time, the native people incorporated the worship of the patron saint into their traditional belief system, which continued to pay allegiance to their ancestor and other pre-Hispanic deities. Under the guise of the Catholic religion, festivals remained an important means of community identity, and the patron saint's feast day was a highly celebrated occasion. As in pre-Hispanic times, these festivals took the form of processions, dances, dramas, games, and feasting with elaborate decorations and flower displays. Fireworks, introduced by the Spanish, also became an important aspect of the celebrations. In many communities, masquerading was part of the performance although Spanish authorities tried to ban it. They also complained about the rowdy character of the festivities and the extravagant spending by members of the *cofradías* who took turns sponsoring the events.

Despite these complaints, Catholic priests working in these communities instructed the Indians to join into the annual Catholic festival cycle, beginning with Christmas and continuing through Holy Week, Corpus Christi, and All Saints and All Souls days. In between were a number of important feast days for the Virgin Mary and other popular saints. Over time, some of the agricultural rituals of the Indians were adapted to the new series of festivals.

Along with the religious feast days, Catholic priests introduced Spanish dramas as a means for teaching Christianity to the Indians. One of the most important was the Moor and Christian pageant that reenacted the battles and final expulsion of the Islamic Moors from Spain in the late fifteenth century. This drama was very popular in Spain, where masked dancers played the role of pagan Moors being defeated by the Spanish and converted to Christianity. Saint James (known as Santiago) was often featured as the "slayer of Moors" mounted on his white horse. The Indian groups in Mexico were taught to act out this masked drama as a symbol of their own defeat by the Spanish and adoption of the new religion.

Other variations of this combat pageant also were introduced into the Mexican Indian communities, such as *Los Doce Pares de Francia* (Twelve Pairs of France) that told the story of the Christian campaigns of the French king Charlemagne against the Moors. A further twist to the combat drama was the acting out of the Spanish conquest of Mexico with masked actors representing Cortés and his men, Catholic priests, the Aztecs, as well as Indians from other ethnic groups.

Christian morality plays also were taught in the Indian communities, with masked actors playing out the struggle between good and evil. One of the most popular was the *Pastorela* drama, performed during the Christmas season, which tells the story of the *pastores* (shepherds), a hermit, and sometimes a rancher, who are traveling to Bethlehem to see the Christ Child. Along the way they are confronted by Lucifer and other devils who try to turn them off their course. Another morality play was the *Tres Potencias* (Three Powers), where Christ, the Virgin Mary, and the Soul fight against the Devil, Sin, and Death. *Siete Vicios* (Seven Vices) featured masked actors who represented vices to be overcome by good Christians. In *La Danza de los Ocho Locos* (The Dance of the Eight Fools), a Catholic priest symbolizes the ability to control human weaknesses.

Holy Week was of particular importance in the Catholic ritual cycle, and the Indians participated in processions and dramas that paid homage to the suffering and crucifixion of Christ. In these pageants the evil characters were the Jews, ahistorically portrayed as slayers of Christ, who were depicted in different types of masks.

The Spanish colonists who settled in cities and ranches throughout Mexico introduced other European masked festivals such as Carnival. This was a celebration of fun, games, dancing, and feasting before the strict forty days of abstinence during the Catholic Lent. Masquerading during this festival took a variety of forms with secular themes. Comical dramas often were acted out that poked fun at outsiders as well as members of the communities.

Little is known about the masks from the colonial era, but some apparently came out of the workshops of *santeros*, or Christian saint makers, who applied their wood-carving and painting skills to produce very sophisticated sculpted faces with glossy finishes portraying realistic human skin tones. Other masks were probably made by craftsmen living within the mestizo/Indian regions, who sold or rented a vari-

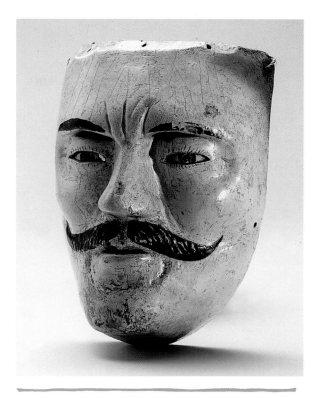

Viejo mask made by a *santero*. Uruapan region, Michoacán (Tarascan), nineteenth century.

ety of costumes to the performers. In some cases, the dancers may have created their own masks from crudely carved wood or other materials at hand.

Even under the umbrella of Catholic and European traditions, the celebrations and masquerading in the Indian communities continued to be criticized by the Spanish authorities. Laws were passed in the sixteenth, seventeenth, and eighteenth centuries to regulate or ban these activities. However, by 1821, when Mexico became independent from Spain, it was clear that such regulations had failed. The Mexican ethnic groups, and the smaller kinship communities within these, had managed to retain aspects of their pre-Hispanic festival practices. Overlaid on top of this were European forms of ritual and celebration, which in some cases coincided with the Indian custom and in others added new dimensions. Masquerading was alive and well and would now be allowed to evolve in the freer atmosphere of the new political regime.

Mexican Masked Festivals in the Twentieth Century

By the beginning of the twentieth century the Republic of Mexico had been divided into states, and most of those in the southern, central, and northwestern part of the country had large concentrations of Indian ethnic groups. It is primarily in these states where masked festivals have continued to thrive (see map).

As in the past, the masked celebrations vary in scale. Smaller fiestas take place in ranches, villages, and *barrios* to honor the patron saint's feast day, and in most cases the sponsorship is still centered in the *cofradía*, or *mayordomía*, system, where one man and his family assume most of the financial responsibility for the year. However, many members of the community take part in organizing and carrying out the celebration, including the groups of masked dancers. Participation is a serious commitment often involving long hours of arduous work. Its success is vital to ensure that the saint and other deities will be pleased and willing to aid in providing good crops and general well-being for the community in the coming year.

Often neighboring ranches, villages, or *barrios* will join together to celebrate larger festivals relating to important dates of the Catholic calendar, such as Christmas, pre-Lenten Carnival, Holy Week, Holy Cross, Corpus Christi, Day of the Dead, and feast days of the Virgin Mary and other saints. In some cases the masqueraders wear similar costumes and perform the same dance while in others each community or *barrio* has its own dance theme that it takes turns performing for the festival crowds.

Some remnants of the *santero* tradition of mask making can still be found in the states of Tlaxcala, Puebla, Oaxaca, Chiapas, and Michoacán, but in most regions masks are produced by craftsmen with sufficient skills to serve the needs of the local area. There are also cases where the dancers make their own masks, such as the Cora Indians of Nayarit and the Mayo and Yaqui men in Sinaloa and Sonora. Although most Mexican masks of the twentieth century have been made of carved and painted wood, other materials also have been used, such as leather, cloth, cardboard, wax, papier-mâché, rubber tire, and metal cans.

The Moor and Christian pageant and related combat dramas continue to be a popular form of masked performance in many states of Mexico, where they are interpreted in a wide variety of ways. The styles of Moor masks also vary from one region to another, but are generally characterized by European features with dark hair and beard. The skin color is often white or light pink, with red paint on the cheeks and/or other areas of the face. In some regions of Guerrero, Puebla, and Veracruz, these masks are entirely red or red in combination with other colors. Along with the masks, Moors generally wear elaborate headdresses to emphasize the exotic nature of their cultural heritage. Sometimes the role of the pagan Moor is replaced by masked representations of the Mexican Indians themselves under such names as *Tastoanes* or *Comanches*. In these instances the masks become more fanciful and often grotesque in their form, coloring, and expression, as seen in Jalisco, Zacatecas, and San Luis Potosí.

Other important characters in the conquest dramas include Santiago and the Christian soldiers. These masks are also usually characterized by European features and dark hair and beard, but unlike the Moors, the skin is generally white or pink with no other colors or facial decorations. However, in the highland region of Puebla the Christian masks may have a red nose and cheeks or be entirely red, since it is said that the Europeans' faces get burned in the high-altitude sun. In most areas of Mexico, Santiago is distinguished from the other Christians by a more elaborate headdress and a hobby-horse fastened to his waist. In the Conquest of Mexico dramas, sometimes called the Dance of the Marquis, Cortés is usually portrayed with abundant amounts of dark hair and beard, in keeping with historical descriptions of the first Europeans seen by the Mexican Indians.

One of the key female characters in this conquest drama is Malinche, the Indian interpreter and mistress of Cortés, who sometimes appears with the mask of a sexy woman with gaudy makeup. In many instances, however, she is portrayed as a sweet young woman, affectionately referred to as *Maringuilla*, or Little Mary. In other dances, the Malinche character relates more to indigenous mythology as the wife or daughter of the Aztec ruler, Moctezuma, and thus symbolizes strength, power, and wisdom for the Indian people. As an extension of this, she may also be viewed as the goddess or queen of the spirit world, commonly known in pre-Hispanic Mexico as Toci or Tonantzin. She often appears in *Negrito*, or Blackman, dances holding a snake, which is linked to the invocation of rain and fertility for the crops.

Another popular form of masked pageantry is the Jaguar, or *Tigre*, dance, performed in various manifestations in the states of Guerrero, Oaxaca, Puebla, Chiapas, and Tabasco, under such names as *Tecuanes, Tlacololeros, Tejorones, El*

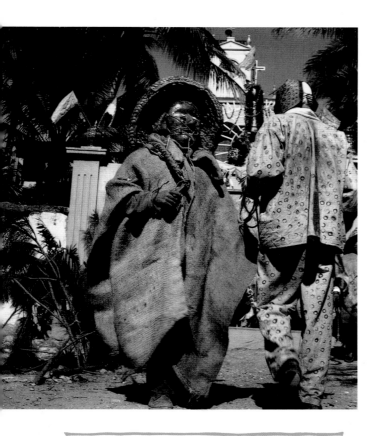

Tlacololero and *Tigre* performing in the *Tlacololero* dance drama.
Mochitlán, Guerrero (Nahua), 1962

Calalá, and *El Pochó*. These dramas have roots in pre-Hispanic theatrical performances in providing humorous commentary on village life as well as addressing concerns about the cultivation of crops and/or keeping a balance among the animal life of the region. A variety of characters appear in these masked performances, ranging from old men, farmers, and hunters to an array of animals. The Spanish word for jaguar, *tigre*, is often translated as "tiger" and their costumes and masks tend to be yellow with black spots, in keeping with the coloring of that cat. The *Tigre* masks are quite diverse in style, ranging from large wooden face coverings, as seen in Acatlán, Puebla, to the painted leather helmet style used in Zitlala, Guerrero, to those made from gourds or wood worn on the top of the head with painted fabric covering the face, as found in Suchiapa, Chiapas.

Other masked pageants commenting on village life also have roots in the pre-Hispanic era. The dance of the old ones, known as *Viejos* or *Huehues*, is found in many areas of Mexico, often with a comic flavor similar to the *Viejo* acts being performed at the time of the Spanish conquest. However, in the highland villages of northern Michoacán, their role is more dignified. Again the style of the old men and women masks varies widely from one region to another, ranging from those in Tabasco, with deeply carved lines in the faces, to Michoacán where they are often beautifully sculpted with glossy skin tones, to Guerrero, Puebla, and Veracruz, where the carving and painting emphasize the comic aspects of the characters.

Other theatrical pageants, such as the *Manueles* in Guerrero and the *Juanegro* in Veracruz and Hidalgo, relate stories of love affairs and the complications these can create within the community. The masks for these dramas are usually carved in sets, portraying the various characters involved in the story. In the *Manueles* pageant, these range from the young lovers to the *viejos* of their families, who take on a particularly comical role. The *Juanegro* dance addresses the problems of race and social class in the battle between a Spanish landlord and his black-skinned foreman over the love of a girl.

The presence of black-faced masqueraders, or *Negritos*, in many parts of Mexico stems from the legacy left by African slaves brought there by the Spanish from the sixteenth to the eighteenth centuries. As laborers and foremen on plantations, the Africans gained considerable respect from the Indian peoples, who recognized their vast array of skills and ability to maintain their dignity despite the difficult conditions. *Negritos* are featured in a variety of dances where they usually wear elegant clothing accented with colorful fabrics and headdresses. In this guise, the *Negrito* often functions as the host for the festival and assumes such roles as clearing the area for the dancers to perform and clowning with the crowd to keep it entertained. Some anthropologists feel the black-faced masqueraders may have antecedents in pre-Hispanic culture as well, when dancers blackened their faces to impersonate deities such as *Ixtililton*, the Aztec god of music, dance, and play. The *Negrito* masks vary from region to region. Some of those from the Costa Chica area of Oaxaca are carved with realistic or exaggerated Negroid features while others from Sierra de Juárez of Oaxaca are more primitive with small tusks projecting up from the sides of the mouth. Many of the *Negrito* masks from Michoacán portray a black face with fine features and sensitive expression.

The *Pastorela* pageants are still performed in many states in the central part of the country, such as Michoacán, Jalisco,

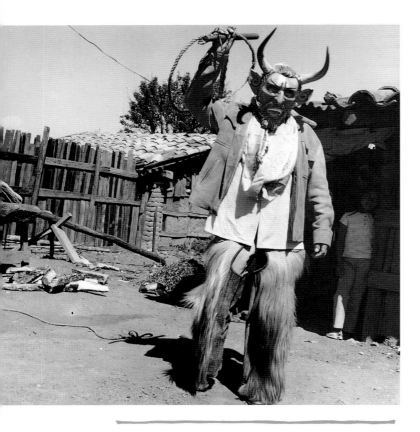

Diablo playing a menacing role during the Holy Week activities. Juxtlahuaca, Oaxaca (Mixtec), 1981.

category and began adding two horns to their images when they found them. The Mexicans had always known their gods to have good and bad sides to their personalities, but the idea of a strictly evil character with two horns was new to the Indian people. Over time, however, they were willing to adopt him as a symbol of their own. Masqueraders in many parts of Mexico enjoy playing this character, not only in the Catholic morality plays but as part of other dances as well. In this latter context, the devils often appear individually and interact in humorous ways with the other performers and members of the crowd. In many instances this joking specifically addresses scandals and other social/political problems within the community and serves as a public forum for breaking down the tensions surrounding them.

Holy Week continues to be an important time within the Catholic ritual cycle, and a few towns in Puebla and Guanajuato are known for their full-fledged masked dramas that reenact and interpret the events of the Passion. In most areas, however, Holy Week is observed with a series of religious processions overseen by priests and lay brothers of the Catholic church. In some Indian communities in San Luis Potosí, Querétaro, Sinaloa, and Sonora, the processions are interrupted by groups of masqueraders portraying the killers of Christ, variously referred to as *chapokobam*, *fariseos* (Pharisees), or *judíos* (Jews). In San Luis Potosí these dancers generally wear devil masks with horns and sharp teeth. However, in Querétaro, Sinaloa, and Sonora the masks also include representations of humorous men and women and a variety of animals.

In some Indian communities the springtime dances of Holy Week are also a time to pay tribute to the ancestors. Among the Cora Indians living in the highlands of Nayarit, this week is dedicated to the initiation rites of the young men. Here a variety of papier-mâché masks are worn that represent their ancestor deities, combined with color symbolism relating to the death of Christ. In the Yaqui and Mayo villages of Sinaloa and Sonora, Easter Sunday is a time for the *Pascola* dancers who wear small wooden masks with features of an old man or goat. He signifies an old one or ancestor who is thought to communicate between the villagers and their gods through the medium of clowning and dance.

Among the Huastec peoples in the states of San Luis Potosí, Veracruz, and Hidalgo ancestors are portrayed in masked performances during All Souls Day observances on

Guanajuato, and San Luis Potosí. One of the main characters is the humorous shepherd, Bartolo, whose mask usually portrays a clean-shaven European male. He is accompanied by the hermit, whose mask may represent a dignified old man with a beard or a decrepit male with extremely wrinkled skin and long hair and beard. The most striking masqueraders in these dramas are the *diablos*, or devils, who often appear in large groups. Their leader, Lucifer, is generally represented with a human face while the others are portrayed as frightening creatures with a mixture of animal and human features, two horns, and sharp teeth. Insects, snakes, and other reptiles may also be attached to their face.

The concept for the *diablos* was introduced by Spanish priests who were following the Catholic biblical reference to an evil (anti-Christian) demon with two horns. These priests considered the Mexican pre-Hispanic deities to fall into this

November 2. These masked actors, known as *Xantolos* (supplicants), symbolically go from house to house asking for leftovers from the harvest season. Their masks range in style from finely carved small faces, often left unpainted, to larger pieces with crude features and bold painting.

Pre-Lenten Carnival is probably the most popular festival in Mexico, when communities come together to feast, sing, dance, and perform lively and humorous masked dramas. These range from the *Tigre* pageants of Oaxaca, Chiapas, and Tabasco to the portrayals of colonial hacienda life in the state of Mexico to the reenactment of the Mexican battle with the French in Puebla. This is also a time to mock other members of the community or important personages from the past, such as seen in Tlaxcala where masqueraders portray and make fun of wealthy Europeans who once lived in this region. In many places Carnival participants don costumes and masks worn for their patron saint's feast day, Holy Week, or other religious festivals, where the characters are converted from a more serious role to one of comedy. Certain types of masquerades are inherently humorous, such as the *Viejos* and *Diablos*, whose antics often take on sexual overtones. Underlying the springtime celebration of Carnival are concerns for the coming agricultural cycle, and aspects of the dances may relate to this theme. Examples of this are found in Tlaxcala, where some masqueraders impersonate Europeans holding open umbrellas as a plea for rain. In the village of Huistán, Chiapas, masked dancers carry stalks of corn in their hands or tied to their clothing as a symbol of fertility for the crops.

The *Tigre* dramas also express issues relating to hunting, the natural environment, and survival of the community.

It is almost impossible to know all of the festivals, types of masquerades, and styles of masks found throughout Mexico in the twentieth century. This book does not attempt to provide that level of information, but it can serve as a general guide to some of the well-known masked festivals and styles of masks specific to each area. In the following pages this information is presented by region and state to help orient the reader to the different areas of Mexico, the Indian groups who live within them, and their festival traditions. A few states, particularly in the north and south of Mexico, are not included in these discussions since masquerading is generally not part of their festival activities today.

The Museum of International Folk Art's extensive collection of Mexican masks provides a visual reference for some of the types and styles found in each state. The majority of pieces date from the mid-twentieth century. There are also a few older examples, as well as some recent masks purchased directly from the makers. One of the primary objectives of this book is to provide accurate identification of the masks' provenience, date, dance, character, and maker, when known. The mask illustrations also are supplemented with photographs of the costumed performances themselves to show the context of the masquerades within the festivals and/or community settings.

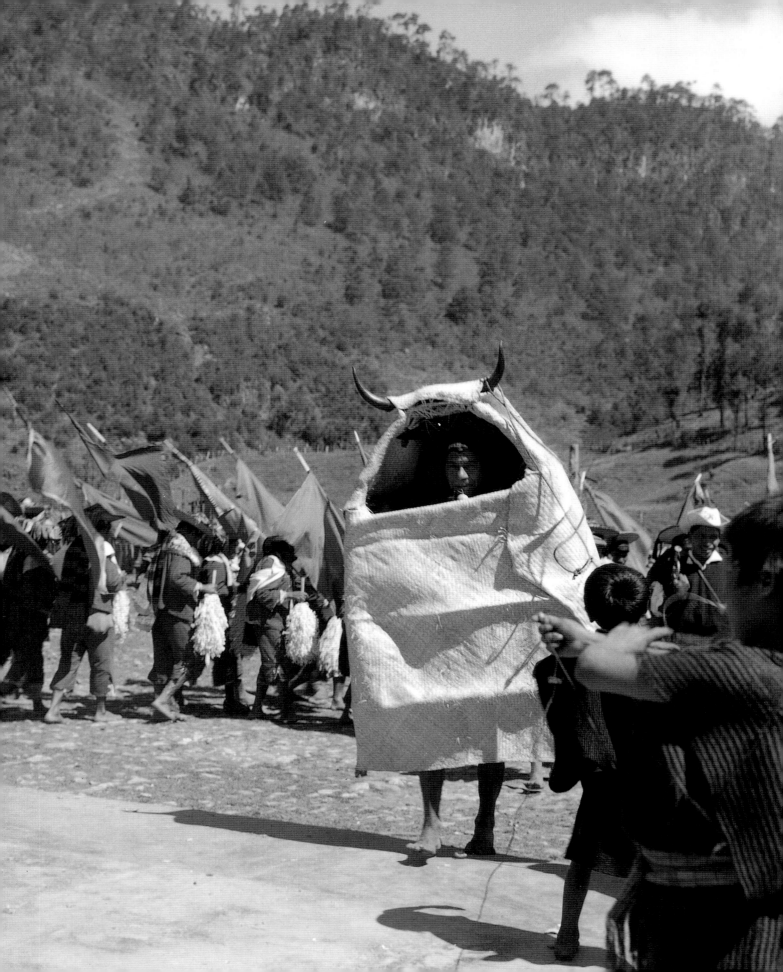

Chiapas

Chiapas, Mexico's southernmost state, was part of the ancient Maya cultural region and is still inhabited by a number of ethnic groups who speak dialects of the Maya language. Although masked dances may take place in other areas, the most accessible are found in communities located in the central part of the state. Tzotzil, Tzeltal, and Tojolabal peoples in the high-plateau region around the city of San Cristobal are particularly involved in celebrating pre-Lenten Carnival, which coincides with the beginning of their planting season. Many of the dances feature animal and hunting themes with a variety of costumes, such as the monkeys of Chamula, the *tigres*, crows, and blackman clowns of Zinancantán, and the *toro* and other animals of Tenejapa. Clowns appear in Huistán carrying stalks of corn. Most of the costumes and masks in this highland region are made from fur, leather, plant fibers, or other natural materials, which may have close ties to pre-Hispanic costuming traditions.

Many of these communities also celebrate their own patron saint's feast day as well as that of San Sebastian (January 20), the patron saint of Chiapas. In Zinancantán the festivities for San Sebastian begin in mid-January and continue through the twenty-fifth, and include a humorous drama featuring a cast of characters—Spaniards, white heads, Lacandon Indians, jaguars, plumed serpents, Moss Wearers, and clowns.

SOUTHEASTERN REGION

In the lower, central valley region around the city of Tuxtla Gutiérrez, Zoque Indian communities such as Ocozocuautla and San Fernando also celebrate Carnival. Masked dances in both of these towns feature a *tigre* and monkeys who are pursued by hunters. In Ocozocuautla there are also other groups such as the *Mahomas*, or Mohammeds, who wear fair-skinned masks with European features. One member of their troupe wears a mask on his back that portrays a pig, *Cochi* or *Cochino*, with an ear of corn in its mouth. Other troupes, known as *Chore*, wear a small version of the *Mahoma* masks and elaborate costumes that are specific to each group.

The feast day of San Sebastian is also celebrated in the central valley, with some of the best-known festivities taking place in the Zoque towns of Suchiapa and Chiapa de Corzo. The majority of men in both of these communities participates in a dance drama known as *Los Parachicos* that features elegant costumes and finely carved masks with European features. Corpus Christi is another important occasion in Suchiapa when men act out a hunting drama, known as *El Calalá* (The Deer). This dance includes a large group of *tigres* who interact with a deer, a plumed serpent, a young boy, and a group of men, known as *Chamulas*, who wear white face paint.

◄ *Toro* (Bull) in Carnival dances, wearing full-body mask made from woven plant fiber. Tenejapa, Chiapas (Tzeltal), 1970.

Two different types of clowns appear in the Carnival festivities in the highland village of Huistán. One type paints its torsos with white lime and covers its faces with scarves. The others wear distinctive dark brown or red leather masks, with mustaches and beards, as seen here. These masks may also be decorated with satin, bells, beads, and grommets to give a more colorful effect. Each of the clowns carries a stalk of corn in his hand or tied to his clothing as a symbol of fertility for the crops.

CLOWN MASK FOR CARNIVAL DANCES

Made by Juan José Aquilar

Huistán, Chiapas (Tzotzil)

c. 1975

H: 20.1 cm

IFAF – Collected in Huistán

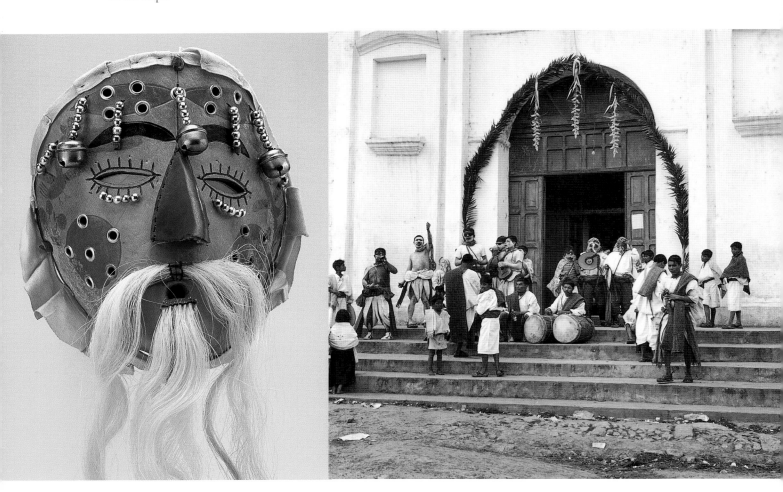

Townspeople and clowns on the steps of the church during the Carnival festivities. Huistán, Chiapas (Tzotzil), 1970.

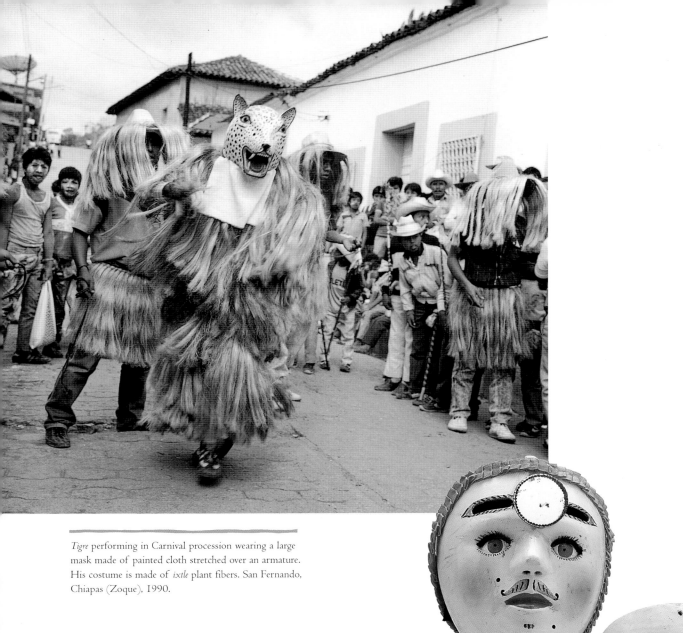

Tigre performing in Carnival procession wearing a large mask made of painted cloth stretched over an armature. His costume is made of *ixtle* plant fibers. San Fernando, Chiapas (Zoque), 1990.

These small *Chore* masks are worn by groups of Carnival masqueraders in the Zoque towns around Tuxtla Gutiérrez. Each group, dressed in its own style of costume, provides lively entertainment by running through the streets, chasing each other as well as innocent bystanders.

CHORE MASKS FOR CARNIVAL DANCES

Made by Agustín Castellano (right only)
Ocozocuautla, Chiapas (Zoque)
c. 1980
H: 15.8 cm
IFAF — Collected in Ocozocuautla

Tigres preparing for the *El Calalá* dance drama performed for the Corpus Christi feast day. Suchiapa, Chiapas (Zoque), 1987.

The large group of *tigres* that participate in the *El Calalá* dance in Suchiapa play the role of aggressors, simulating combat with the other masqueraders and molesting the spectators. The mask consists of a helmet made from a gourd (as seen here) or sculpted in wood that is worn on the top of the head. Painted cloth is attached to this, which hangs down to cover the dancer's face and neck.

TIGRE MASK FOR *EL CALALÁ* DANCE

Suchiapa, Chiapas (Zoque)
c. 1960
H: 14 cm
MNM – Gift of the Girard Foundation

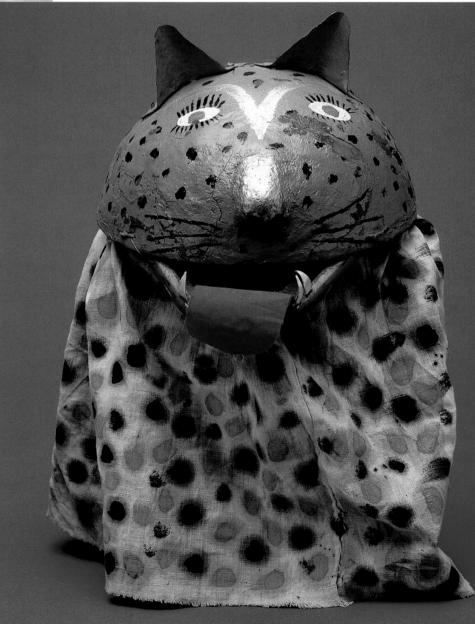

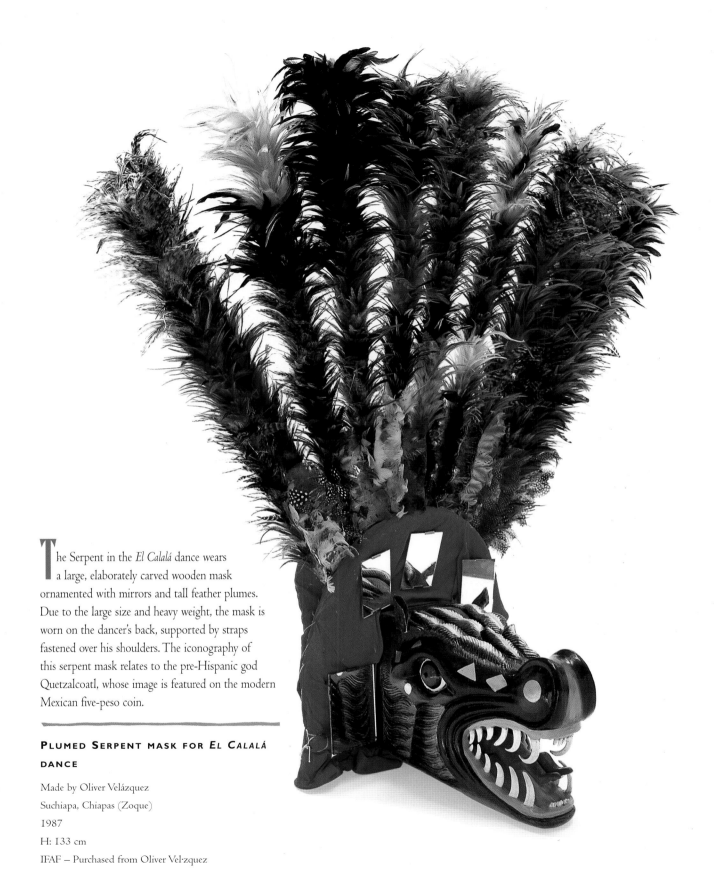

The Serpent in the *El Calalá* dance wears a large, elaborately carved wooden mask ornamented with mirrors and tall feather plumes. Due to the large size and heavy weight, the mask is worn on the dancer's back, supported by straps fastened over his shoulders. The iconography of this serpent mask relates to the pre-Hispanic god Quetzalcoatl, whose image is featured on the modern Mexican five-peso coin.

PLUMED SERPENT MASK FOR *EL CALALÁ* DANCE

Made by Oliver Velázquez
Suchiapa, Chiapas (Zoque)
1987
H: 133 cm
IFAF – Purchased from Oliver Velázquez

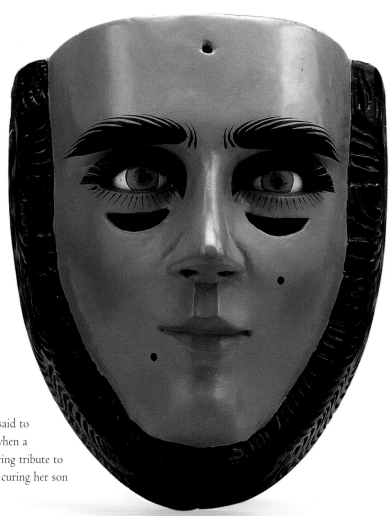

The *Parachicos* performance is said to derive from colonial times when a woman in the village began paying tribute to San Sebastian for miraculously curing her son of a terrible illness, thus the name *para chico* (for the boy). Today this event features hundreds of elegantly dressed dancers wearing *santero*-style masks with European features and glass eyes. They parade and dance through the village for several days paying homage to their patron saint, San Sebastian.

PARACHICO MASK FOR FEAST DAY OF SAN SEBASTIAN

Made by Eloy Moreno Camacho
Chiapa de Corzo, Chiapas (Zoque)
1983
H: 18 cm
IFAF – Purchased from Eloy Moreno Camacho

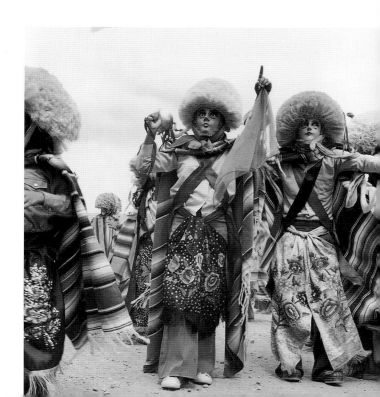

Tabasco

*T*he state of Tabasco, to the north of Chiapas, also is inhabited by ethnic groups of Maya origin spread out in different geographical regions. In the north are the Chontal peoples who live in the villages of Nacajuca, Tecoluta, and Tamulté de las Sabanas where a variety of masked dances are performed for their patron saints' feast days. One of these is a version of the Moor and Christian drama that features a battle between David and Goliath, supported by other characters such as San Gabriel, a group of Christians, Roman centurions, and *Negritos*. The *Baila Viejo* (Dance of the Old Ones) is also found here where masqueraders often perform in a stooped position in imitation of very old people. Another, the *Danza del Caballito*, includes one performer who wears a mask with distinct indigenous features. Throughout the Chontal region of Tabasco, masks are characterized by finely carved facial features, including wrinkles and other subtleties.

Another group of Maya lives in the valley on the interior side of the Usamacinta River next to the border with Chiapas. Here, the feast day of San Sebastian and Carnival are particularly important times for celebration. One of the most popular dances in Tenosique, Boca de la Sierra, and in other villages of this region is a hunting drama known as *El Pochó*, referring to a Maya deity thought to have originated here. Several dozen dancers take part who are divided into three groups, including *tigres*, old women (*pochoveras*), and the *cojós*. Participants in this latter group wear crude or grotesque masks and often tie leaves around their bodies to signify a good harvest for the coming year.

◄ *Parachicos* participating in the San Sebastian feast day celebrations. Chiapa de Corzo, Chiapas (Zoque), 1978.

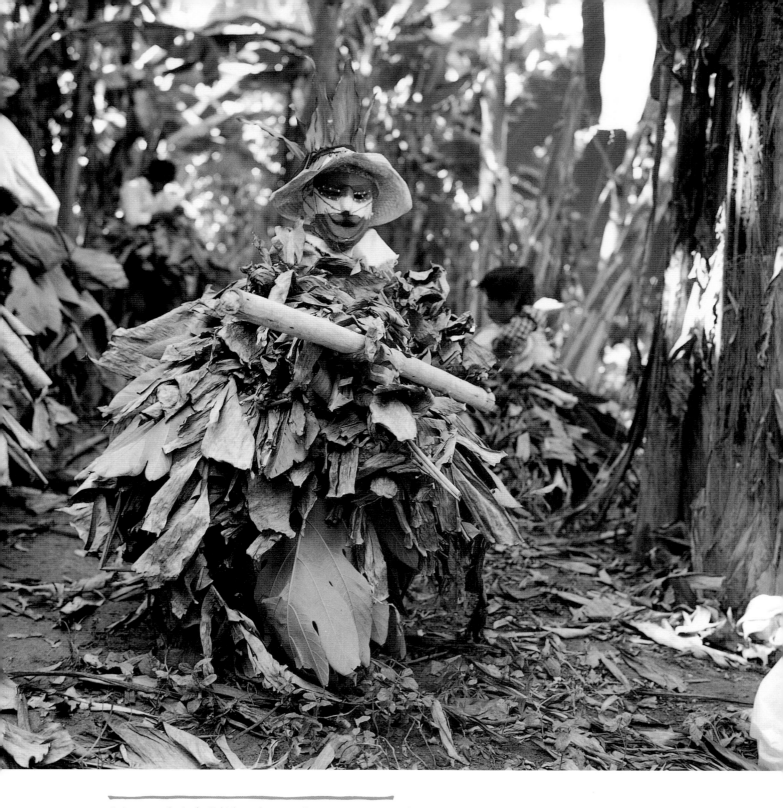

Cojó masquerader in the *Pochó* dance drama wearing a costume
profusely decorated with leaves. Boca de la Sierra, Tabasco (Maya),
1988.

The dance of *El Pochó* is performed in the Maya town of Tenosique and in neighboring villages for Carnival and the feast day of San Sebastian. The performance relates to hunting and agriculture and includes several dozen dancers divided into three groups. One of these, known as *Los Cojós*, wears very crude masks, as seen in this older example. More recently, mask makers have painted bold swirling patterns on the faces, using brightly colored automotive paint and air brushes.

▼

COJÓ MASK FOR *EL POCHÓ* DANCE

Tenosique, Tabasco (Maya)

c. 1945

H: 20 cm

IFAF – Collected in Tenosique

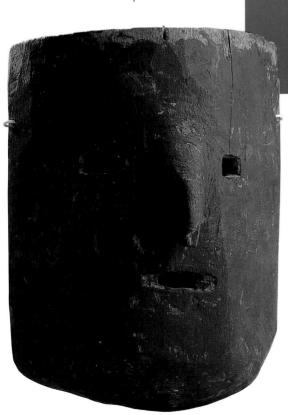

▲

The *Cojó* dancers in Tenosique often tie fresh or dried leaves around their shins to signify a good harvest for their crops. A major part of their performance is to hunt a group of *tigres* who manage to escape, thus keeping an equilibrium among the animal life of the region. In this example, the *Cojó* mask is painted in the colors and markings of his prey, while the word *corazón* (heart) is written across his forehead. The mask makers in this area are free to add such personal touches as this or the dancer's initials, and today you will often see commercial plastic stickers decorating the faces as well.

COJÓ MASK FOR *EL POCHÓ* DANCE

Tenosique, Tabasco (Maya)

c. 1945

H: 21.5 cm

IFAF – Purchased in Tenosique

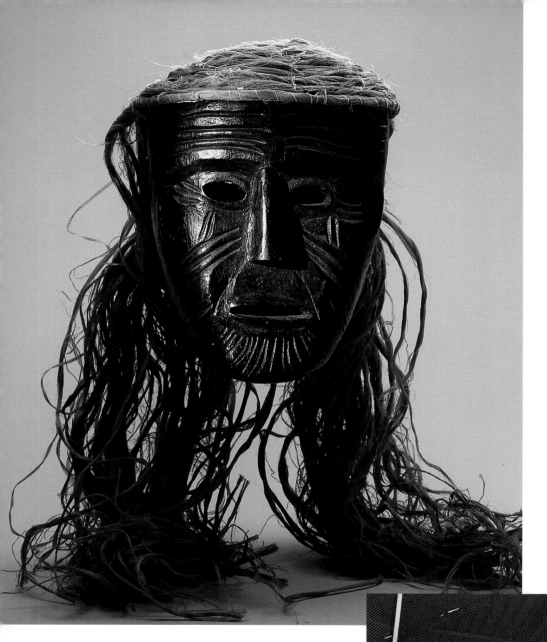

aila Viejo masks worn by Chontal people in the coastal area of Tabasco are distinguished by lines incised into the face that give the effect of wrinkled skin on a very old person. These masks are often left unpainted or given a brown coating, as seen in this example. The hair is made from *jolosín* plant fibers. The performance usually consists of two masked dancers, one portraying a male and the other a female.

BAILA VIEJO MASK FOR THE BAILA VIEJO PERFORMANCE

Nacajuca, Tabasco (Chontal)
c. 1965
H: 19 cm (mask only)
IFAF – Purchased from Jaled Muyaes and Estela Ogazón

Masquerader performing the *Baila Viejo*.
Nacajuca, Tabasco (Chontal), 1988.

Puebla

Puebla is rich in masked dances carried out by a number of different ethnic groups spread throughout the state. In the southern Mixtec/mestizo town of Acatlán a version of the tiger drama, known as the *Danza de los Tecuanes*, is performed for the Day of the Dead and the feast day of the town's patron saint, San Raphael. It features a number of masked characters, including a group of comical old men, a devil, death, a *tigre*, and other animals.

Carnival is an important celebration in the village of Huejotzingo, located northwest of the city of Puebla, where mestizo and Nahua peoples act out a pageant about the abduction of a Spanish magistrate's daughter by the Mexican bandit Agustín Lorenzo. Alongside this drama is a reenactment of the Battle of the Fifth of May, commemorating the Mexican army's victory over the French troops at Puebla in 1862. The participants wear semihistoric costumes and masks, often made of molded leather, portraying the French and Mexican soldiers as well as those of the Mexican Indian forces.

Carnival is also celebrated in towns along the northwestern border with Tlaxcala, where dancers wear very fine masks and costumes that portray European dandies and hacienda owners of the nineteenth century, similar to what is found in Tlaxcala. In the town of Chuatenco, masqueraders present short plays about the life of their village.

The Nahua community of Huiluco, in the southeastern part of the state, is also known for its lively Carnival festivi-

ties that include a group of dancers, called *huizos*, who act out a battle with the inhabitants of the different *barrios*. These revelers wear painted leather masks over their faces and woven straw mats around their bodies.

Nahua, Otomí, Totonac, and Pepehua peoples live in the northern highland area of Puebla, where other types of dances are performed for saints' feast days. This region is famous for the "flying" performances of the *Voladores* and *Quetzales*, but the masks, if worn at all, consist only of scarves. One of the most popular masked dances in the highlands is the Moor and Christian drama, which generally features Santiago. In many villages, such as Cuetzalan, Santiago wears a hobbyhorse around his waist and a special hat but no face covering. His Christian assistants, known as Santiagueros, wear red or white-and-red masks with pointed noses while their opponents, the Moors and Roman soldiers, *Pilato* and *Sabario*, wear masks of fair skin and dark hair. In some villages, however, the Moor and Roman masks may also be red or white and red.

The *Negrito* dances of this highland region feature elegantly dressed men wearing hats decorated with mirrored filaments and strings of glass beads. The troupe usually consists of twelve men, but only two of them wear masks and act as clowns to keep the crowd's attention on the dance. During the performance, the *Negritos* interact with the female character *Malinche*, played by a young boy who wears a dress and hat but no mask. She carries a wooden serpent that even-

tually escapes and "bites" one of them, but in the end he is revived and the snake is killed. This involvement with the snake has underlying symbolism relating to rain and fertility of the local crops.

A comical dance of the Dandies, known here as *Huehuetones*, is also performed in some of the highland towns. The masks and costumes of the dancers make fun of Spanish and French landlords who once lived in the region. Another humorous dance from this region is the *Matarachines*, performed in conjunction with a puppet show. The participants include a *Catrin*, a *Maringuilla*, a clown, and a dog. The clown's mask has bold patterns on it in imitation of the face paint seen on circus clowns.

Holy Week is particularly important in the Totonac highland village of Nanacatlán, where a masked drama is performed that syncretizes pre-Hispanic and Christian traditions. Here the *judíos* (figures representing Christ's persecutors) dress as tattered men, some wearing wooden masks and others covering their faces with rags. *Viejos* or *Huehuetones* also take part by dancing and performing humorous pantomimes in the church in celebration of the resurrection of Christ and the return of the sun.

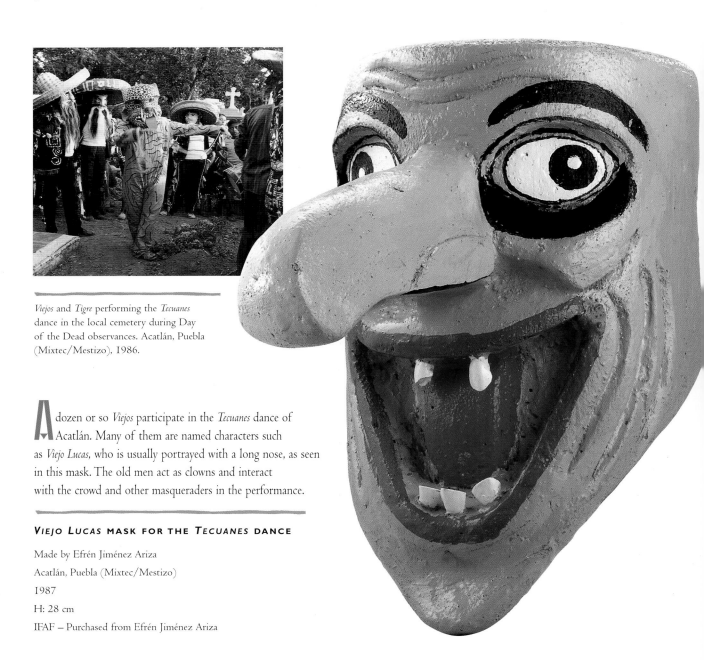

Viejos and *Tigre* performing the *Tecuanes* dance in the local cemetery during Day of the Dead observances. Acatlán, Puebla (Mixtec/Mestizo), 1986.

A dozen or so *Viejos* participate in the *Tecuanes* dance of Acatlán. Many of them are named characters such as *Viejo Lucas*, who is usually portrayed with a long nose, as seen in this mask. The old men act as clowns and interact with the crowd and other masqueraders in the performance.

VIEJO LUCAS MASK FOR THE TECUANES DANCE

Made by Efrén Jiménez Ariza

Acatlán, Puebla (Mixtec/Mestizo)

1987

H: 28 cm

IFAF – Purchased from Efrén Jiménez Ariza

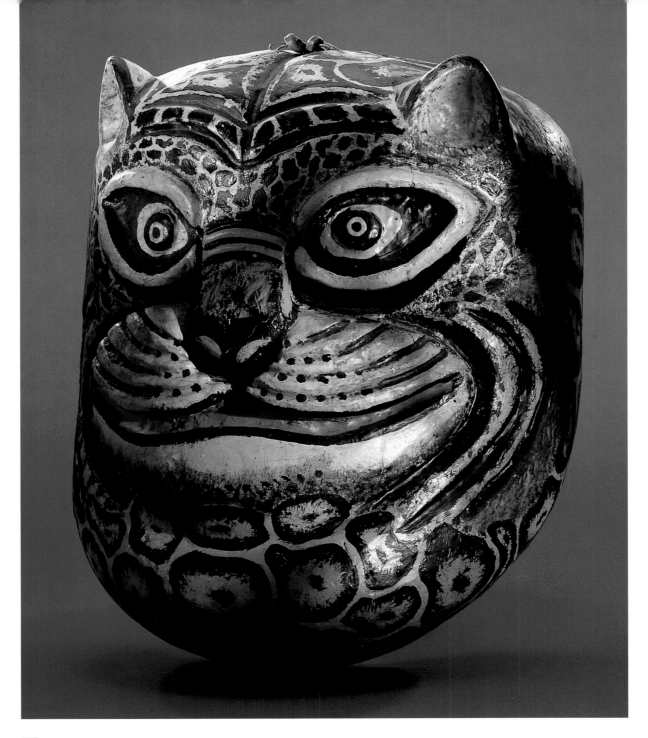

ecuanes means "wild beast," and the *tigre* masks worn for this pageant in Acatlán are generally very large, as seen in this example. This masquerader participates in a hunt-and-capture scene with a dog and other masked dancers, in a similar fashion to the *tigre* dramas found in Guerrero, Oaxaca, and Chiapas. As in all of these, the performance has underlying symbolism relating to rain, fertility, and a good harvest season for the agricultural crops.

TIGRE MASK FOR THE TECUANES DANCE

Acatlán, Puebla (Mixtec/Mestizo)

c. 1965

H: 39.3 cm

MNM – Gift of Kathleen and Robert Kaupp

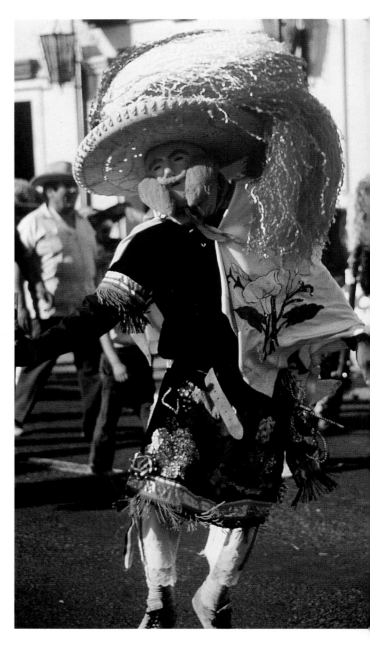

Different types of Mexican and French military groups appear in the Huejotzingo Canival drama "Battle of the Fifth of May," such as the *Serrano,* or Mexican highlander, portrayed in this mask. Although each regiment has its own style of costume, almost all of the masks are made from molded leather, as seen here. The groups are distinguished by facial painting and the color and style of eyebrows, mustache, and beards made from animal or human hair.

Elegantly dressed masquerader participating in the Carnival drama. Huejotzingo, Puebla (Mestizo), 1987. Photograph by Jim Pieper.

EL SERRANO MASK FOR CARNIVAL DANCE DRAMA

Made by Carlos Cozano

Huejotzingo, Puebla (Mestizo)

c. 1965

H: 32.5 cm (with beard)

MNM – Gift of Kathleen and Robert Kaupp

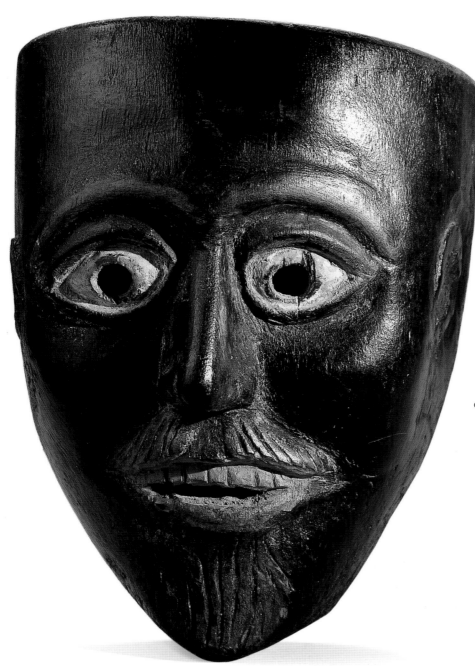

Among the *Negrito* dance troupes, only two males actually wear masks. They play the role of clowns or buffoons and interact with the audience. This *Negrito* mask from the town of Cuetzalan is well carved with a slightly comical expression.

NEGRITO MASK FOR THE DANCE OF THE NEGRITOS

Cuetzalan, Puebla (Nahua)
c. 1950
H: 23 cm.
IFAF – Purchased from the Cordry collection

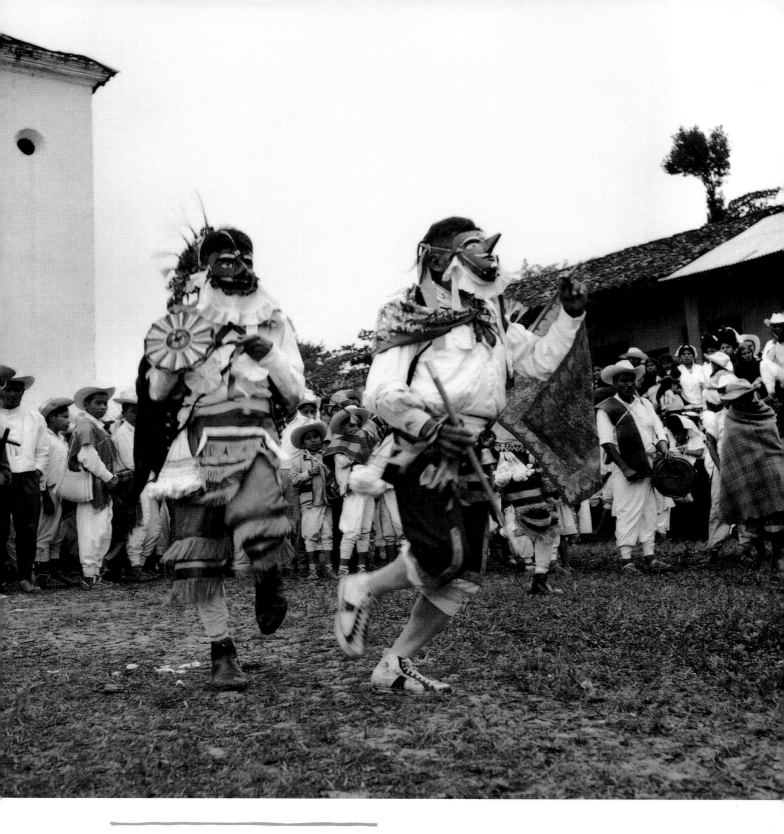

Performers in the Moor and Christian dance drama.
Cuetzalan, Puebla (Nahua/Otomí), 1963.

Santiago is one of the main characters in the Moor and Christian dramas performed in the highland town of Cuetzalan and the surrounding area. He wears a small two-piece hobbyhorse attached to the front and back of his waist but is unmasked. His Christian assistants, known as *Santiagueros*, wear white masks with black beards and red dots on the nose and cheeks, as seen in this example. Although this is unusual for a Christian mask in most regions of Mexico, the use of red on the face here is said to portray the sunburn that the fair-skinned Europeans get in the high-altitude sun.

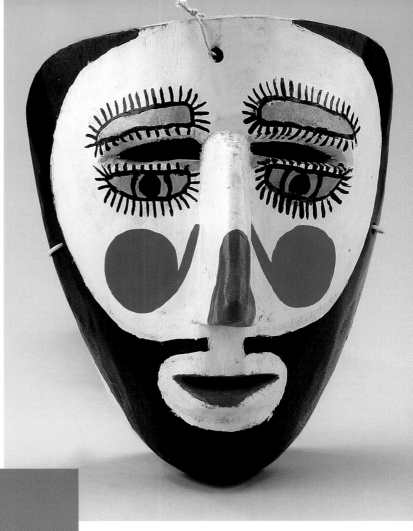

SANTIAGUERO MASK FOR THE MOOR AND CHRISTIAN DANCE DRAMA

Cuetzalan, Puebla (Nahua/Otomí)

c. 1980

H: 19.5 cm

IFAF – Purchased in Cuetzalan

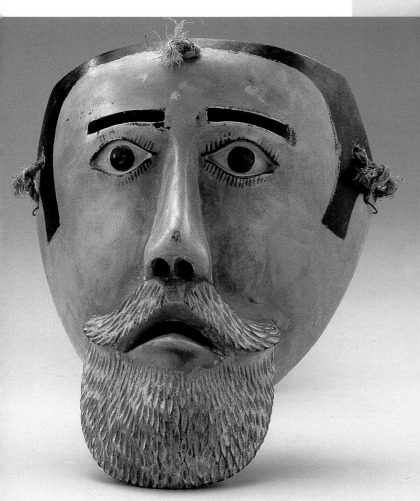

Many of the Moor masks worn in the highland region of Puebla are also different from those found in other areas of Mexico, characterized here by fair skin and dark hair, with no red on the cheeks or other parts of the face. This beautiful *santero*-style mask from the town of Tlaxco has a gray mustache and beard and may actually portray one of the Roman soldiers in this pageant, *Pilato* or *Sabino*, whose characters are distinguished by the length of their beards.

MOOR OR ROMAN MASK FOR MOOR AND CHRISTIAN DANCE DRAMA

Tlaxco, Puebla (Nahua/Otomí)

c. 1950

H: 21.5 cm

MNM – Gift of Rick Dillingham

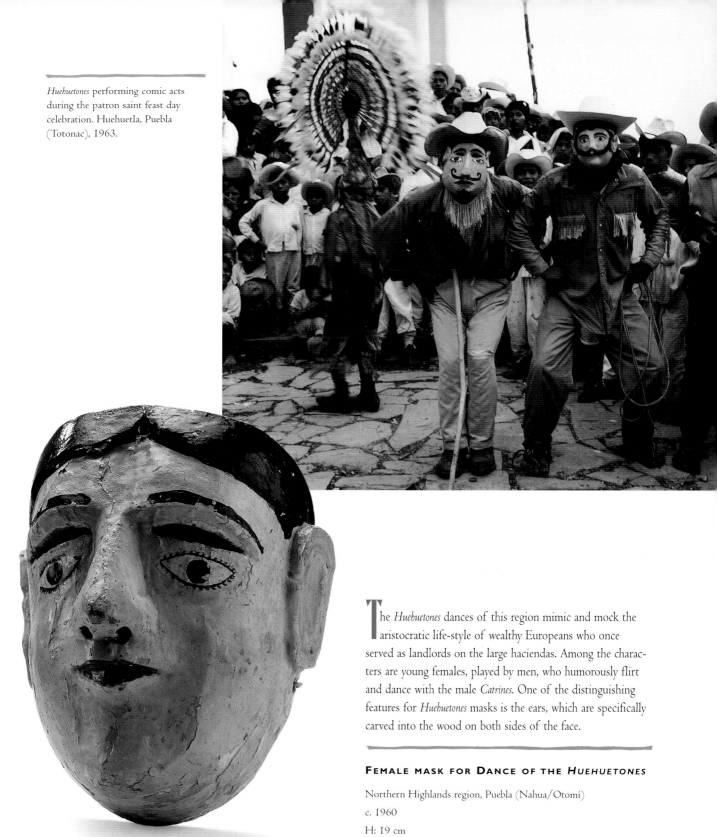

Huehuetones performing comic acts during the patron saint feast day celebration. Huehuetla, Puebla (Totonac), 1963.

The *Huehuetones* dances of this region mimic and mock the aristocratic life-style of wealthy Europeans who once served as landlords on the large haciendas. Among the characters are young females, played by men, who humorously flirt and dance with the male *Catrines*. One of the distinguishing features for *Huehuetones* masks is the ears, which are specifically carved into the wood on both sides of the face.

FEMALE MASK FOR DANCE OF THE *HUEHUETONES*

Northern Highlands region, Puebla (Nahua/Otomí)

c. 1960

H: 19 cm

IFAF – Purchased from Robert Ellis

Hidalgo

Masked festivals in Hidalgo are found in Huastec, Nahua, and Otomí communities situated along the borders with San Luis Potosí and Veracruz, and many of the dances and mask types are shared by the same ethnic group on both sides of the state lines. Carnival is one of the most popular celebrations throughout the region, and in many communities masks worn for Holy Week, Day of the Dead, and patron saint feast day performances are reused and transformed into more comical characters for Carnival.

Among the Nahua people living in the northeastern part of the state, around the city of Huejutla de Reyes, the masks are generally small in size and represent animals and humans, often with stylized features. Further south in such Otomí towns as Carpinteros, Metzquititlan, and Agua Blanca, the masks are somewhat more realistic, featuring a range of characters, such as old men, eagle and jaguar knights, as well as animals and birds. Carpinteros is known as a center for producing a good majority of these masks, both for internal use and for sale to outside collectors. Traveling further south and east to the Otomí towns of El Nante (near Tenango de Doria) and San Bartolo Tutotepec, Carnival dancers wear a distinctive type of mask known as the Chivo, or goat.

The Huastec people in the northern part of Hidalgo, living in villages such as Huautla, Atlapexco, and Chiliteco and over the borders into Veracruz and San Luis Potosí, perform a lively masked drama known as Juanegro. This pageant features a comical conflict between a rancher and his black foreman, wearing small masks that usually are carved as a set, painted white, black, or sometimes red. The Huastec are also known for the masked Xantolos (supplicants), who go from house to house during the Day of the Dead activities.

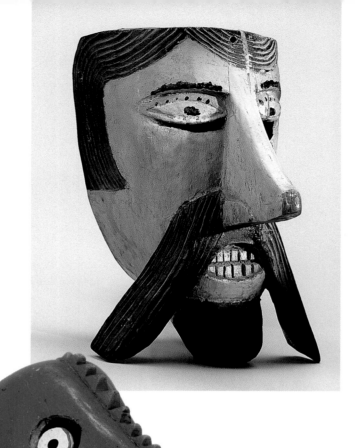

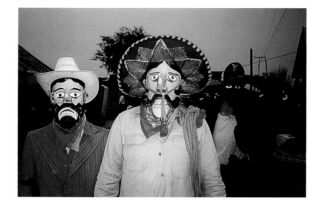

Viejo masqueraders enjoying the Carnival festivities. Carpinteros, Hidalgo (Otomí), 1992. Photograph by Estela Ogazón.

Viejo (old men) masks worn in the Carpinteros region of eastern Hidalgo and in other towns across the border into Veracruz are characterized by realistic features presented in a somewhat exaggerated and humorous fashion. The lines of the hair and mustache are emphasized with incising in the wood. This mask has suffered some damage to the left eye, probably during the rowdy activities of the *Conquista* drama performed for the feast day of the patron saint.

VIEJO MASK FOR CONQUISTA DRAMA AND CARNIVAL DANCES

Carpinteros, Hidalgo (Otomí)
 c. 1955 H: 25 cm
 IFAF – Purchased from Jaled Muyaes and Estela Ogazón

Carnival groups often dress in matching costumes with a single theme. A few years ago a group in Carpinteros masqueraded as brightly colored birds. Among these the hummingbird masks were particularly impressive, with the long beak and face carved out of a single piece of wood. This style of mask has also become popular with outside collectors, and some mask makers in the Carpinteros region have been carving a variety of charming animal and bird masks strictly for this market.

HUMMINGBIRD MASK FOR CARNIVAL DANCES

Carpinteros, Hidalgo (Otomí)
c. 1990
H: 57 cm
IFAF – Purchased from Sergio Roman Rodriguez

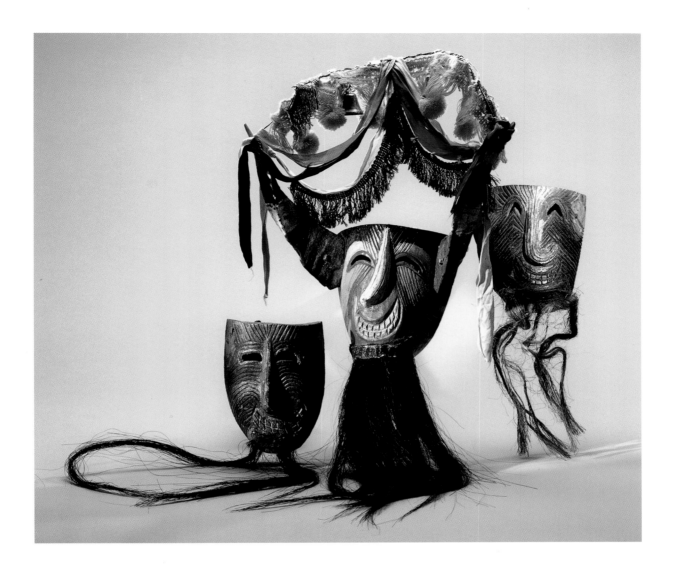

The small *Chivo*, or goat, masks worn for Carnival in El Nante and the neighboring town of San Bartolo Tutotepec are carved in hardwood, allowing for little articulation of facial features. However, a sinister/whimsical expression is achieved through an exaggerated twist to the nose and wide grin in the mouth. Relief carving around the eyes and face further add to the dynamic effect. Beards are attached with a strip of leather across the chin. All *Chivo* masks originally have horns, often decorated with ribbons, tassels, and bells, as seen in the center example, but these are often removed when the masks are sold to outsiders. Older masks were generally painted in subdued pigments, while more recent ones are decorated in brighter colors.

CHIVO MASKS FOR CARNIVAL DANCES

(left and right) El Nante, Hidalgo (Otomí)
1950s
H: 17 cm (without beard)
IFAF – Purchased from the Cordry collection

(center) San Bartolo Tutotepec, Hidalgo (Otomí)
c. 1975
H: 81.5 cm (with horns and ornaments)
MNM – Gift from Rick Dillingham

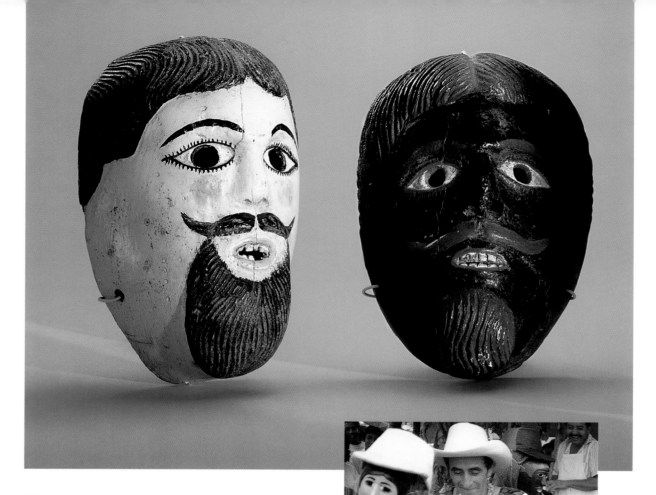

The *Juanegro* dance drama acts out the humorous story of a battle between a Spanish hacienda owner and his dark-skinned foreman over the love of a girl. Eventually the patron wins, symbolizing the injustice of power that the rich have over their workers' lives. However, in some versions of the dance, the woman waits for Juan Negro to get free and goes off with him in the end. The female character is played by a young man, who wears a scarf rather than a mask.

PAÑOL (ESPAÑOL) AND JUAN NEGRO MASKS FOR THE JUANEGRO DANCE DRAMA

Huasteca region, northern Hidalgo/Veracruz (Huastec)

c. 1970

H: 18.9 cm

IFAF – Purchased from Victor Fosado

Masqueraders in front and behind a man dressed as the female girlfriend in *Juanegro* dance drama. Huautla, Hidalgo (Huastec), 1995. Photograph by Sam Lemly.

Veracruz

Veracruz has a diverse ethnic population of Huastec, Nahua, Otomí, and Totonac peoples whose masked festivals continue a strong and colorful tradition. As in the neighboring state of Hidalgo, the Huastec people living in the northern part of Veracruz perform the *Juanegro* drama. Along the western border, the small masks are identical to those worn in Hidalgo, but in the Huastec communities further east, around the city of Chinampa, they are larger and more stylized. This drama is performed for patron saint feast days and other important dates of the Catholic calendar.

Carnival is a festive time among the Nahua and Huastec peoples in and around the city of Tempoal, on the northwestern border with Hidalgo. Many of the masqueraders play the comical role of *Viejos*, wearing well-carved masks with somewhat realistic features. One of the humorous female characters is known as *Mojica*, whose mask is distinguished by a chubby face and carved hair that extends across her forehead and down around her cheeks. A little further south in Nahua and Otomí communities such as Huayacocotla, Zontecomatlán, and Zilacatipan, the Carnival masks are similar in style to those worn in neighboring villages across the border in Hidalgo. Again, the comical *Viejos* are a popular form of masquerade, along with a wide range of animals. Some of the masks are reused from other types of dances, such as the red-faced Moors with long, sharp noses and the *Conquistas*, whose masks are distinguished by large sculptural forms projecting out from the center of the face. Carnival performances in Nahua communities around

Alto Lucero in the central part of Veracruz feature masked bulls with elaborate headdresses. Moor masks are also worn for Carnival, many of which are very stylized, with a dark complexion and red hearts painted on the cheeks.

Moor and Christian dramas are common throughout Veracruz, often performed for patron saint feast days. In the Totonac region around Papantla, masqueraders perform a special version known as "*Tocotines*, Moors, and Christians," in which the *Tocotines* represent Mexican Indians. They wear stylized red-and-white masks with bold black-and-white stripes that enhance the eyebrows and mustache.

The Totonac people in this area also perform *Negrito* dramas similar to those found in the neighboring highland region of Puebla. The troupe of dancers wears elegant clothing with heavily decorated hats, but only two of them wear *Negrito* masks and interact with the crowd. Their performance includes the character *Malinche*, or *Marinquilla*, who carries a whip and a menacing snake, both of which relate to petitions for rain. The young boy playing this female role wears a dress, hat, and sunglasses but no mask.

Holy Week is an important time of year, particularly in San Pablo (a municipality of Papantla), where masked performers take on the role of biblical characters. Of particular interest are the portrayals of Judas Iscariote and Poncio Pilato, who drag heavy chains through the interior of the church. They wear oil-skin ponchos and magnificent masks with yellow complexions.

31

This style of *Juanegro* masks is distinctive to Huastec communities around the northern Veracruz city of Chinampa. Although more abstract than the *Juanegro* masks found to the west, in the border region with Hidalgo, their humorous expressions add to the comical nature of the drama.

PAÑOL (ESPAÑOL) AND JUAN NEGRO MASKS FOR JUANEGRO DANCE DRAMA

Chinampa region, Veracruz (Huastec)

c. 1980

H: 21 cm (masks only)

IFAF – Purchased from Barbara and Robin Cleaver

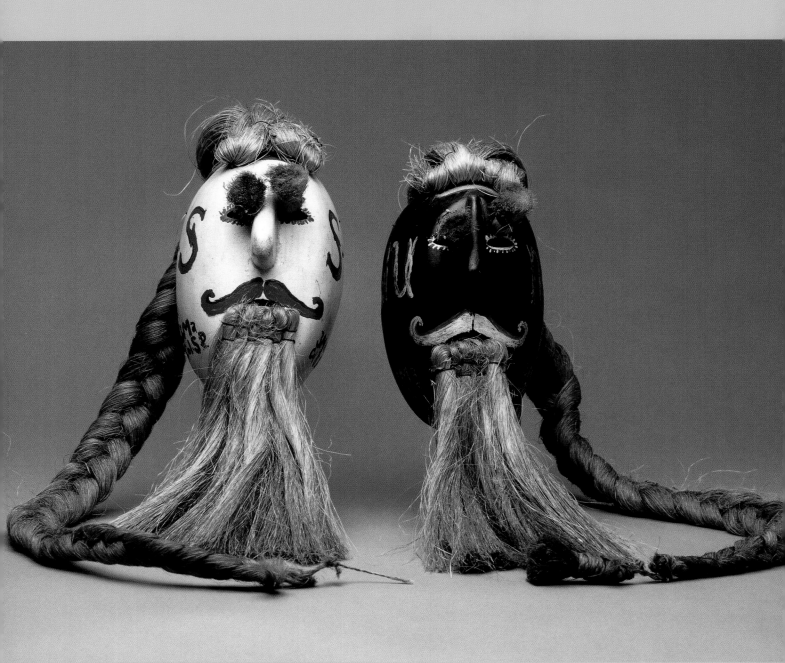

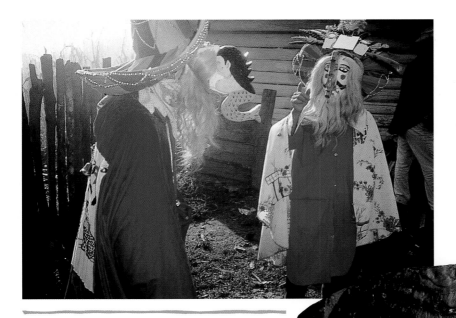

Conquista masqueraders participating in Carnival celebrations. Atistace, Veracruz (Nahua/Otomí), 1992. Photograph by Estela Ogazón.

Many of the Moor masks worn in this border region of Veracruz, Hidalgo, and Puebla are characterized by red faces with prominent noses and delineated carving of the hair and mustache. In this example, the large white eyes stand out against the red face, adding to the humorous expression of the character. This comical role is further emphasized when the Moor masks are reused for Carnival.

MOOR MASK FOR MOOR AND CHRISTIAN DRAMAS AND CARNIVAL DANCES

Zontecomatlán and Huayacocotla region, Veracruz (Nahua/Otomí)

c. 1975

H: 17 cm

IFAF – Purchased from Victor Fosado

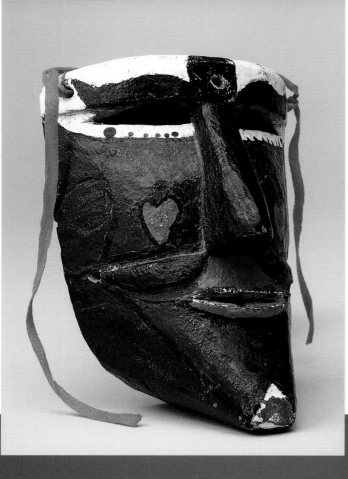

The stylized features and coloring of this Moor mask are typical of those worn for Moor and Christian pageants in this central region of Veracruz. The painting around the eyes, mouth, and chin create a stern expression offset by the red hearts on the cheeks. As seen elsewhere, the Moors masks are often reused for Carnival where they take on a more humorous character.

MOOR MASK FOR MOOR AND CHRISTIAN DRAMAS AND CARNIVAL DANCES

Alto Lucero region, Veracruz (Nahua)

c. 1950

H: 18.5 cm

IFAF – Purchased from Martha Egan, Pachamama

The bull masks worn for Carnival in the Alto Lucero region of Veracruz are known for their wonderful expressions and lively painted designs. Besides the large horns, many of these masks are decorated with mirrors and floppy ears, in this example created from tire inner tubes.

BULL MASK FOR CARNIVAL DANCES

Alto Lucero, Veracruz (Nahua)

c. 1975

H: 29.5 cm

IFAF – Purchased from Jaled Muyaes and Estela Ogazón

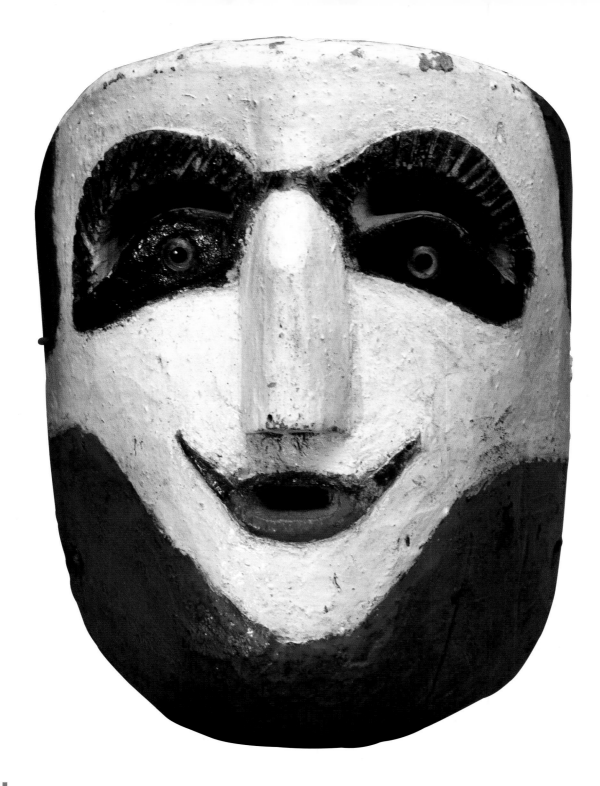

In January each year, Totonac people in the Papantla region of Veracruz perform a variety of dances, including their own version of the Moor and Christian drama. Some of the main characters are the *Tocotines*, representing Mexican Indians, whose masks are generally painted red and white with large, drooping eyes. Although not portrayed in this example, the eyebrows and mustache are often accentuated by bold black-and-white stripes.

TOCOTIN MASK FOR DANCE OF THE *TOCOTINES*, MOORS, AND CHRISTIANS

Papantla region, Veracruz (Totonac)

c. 1960

H: 19.5 cm

MNM – Gift of the Girard Foundation

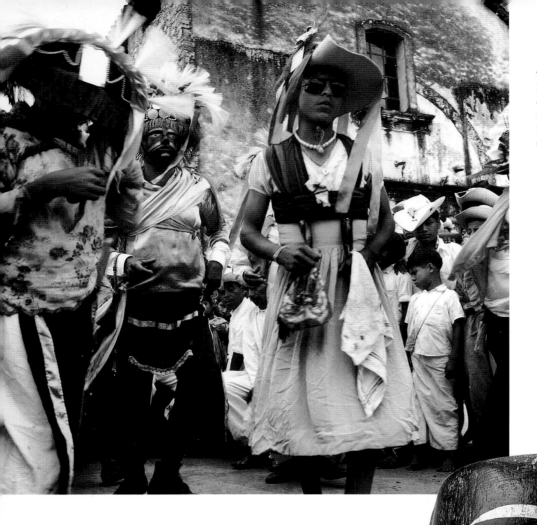

Dance of the *Negritos* with one masked clown and other unmasked dancers, including a young man dressed as Malinche wearing sunglasses and hat. Olintla, Veracruz (Totonac), c. 1980.

The Dance of the *Negritos* is also performed in the Papantla region during the January festival season. It includes a group of costumed performers representing a foreman, field workers, and clowns. The clowns (shown) alone wear masks that are well carved with realistic features and somewhat comical expressions.

NEGRITO MASK FOR DANCE OF THE *NEGRITOS*

Papantla region, Veracruz (Totonac)

c. 1975

H: 19.6 cm

IFAF – Purchased from Jaled Muyaes and Estela Ogazón

San Luis Potosí

San Luis Potosí has a large population of Huastec people living in towns and villages in the southeastern corner of the state that borders on Veracruz and Hidalgo. Here, as is true for the neighboring states, Carnival, Holy Week, and Day of the Dead are important occasions for masked performances, and in some cases the same masks appear in all three celebrations. Many of these take the form of *diablos*, or devils, characterized by two horns or antlers projecting from the top portion of the mask. During Holy Week the devils may portray *judíos*, or Jews (a generic term for Christ's persecutors); Comanches (wild Indians) for Day of the Dead dances; and satirical devil-comedians during Carnival. Other groups of Huastec masqueraders, known as a *Xantolos* (supplicants), appear only during the Day of the Dead with masks portraying old men or ancestors with crude features.

The Pame people living in the central part of the state, in the areas around Rioverde and Ciudad Maíz, also include devil masqueraders in their Holy Week observances. The *diablo* masks from Ciudad Maíz are generally large with sharp teeth and horsehair beards. At least one mask maker in Rioverde has produced devil masks from recycled tin cans, leaving the label exposed over the facial area as a decorative touch.

Pastorela dramas with groups of masked *diablos* also are performed in mestizo towns in the northern part of the state, around Matehuala. Some craftsmen in this city have also utilized metal cans to construct the devil masks, but here the label is turned to the inside and the exterior metal surface is concealed in paint.

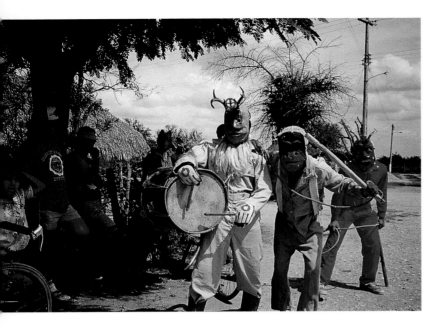

Judíos performing for bystanders during Holy Week activities. El Tamuin, San Luis Potosí (Huastec), c. 1985. Photograph by Estela Ogazón.

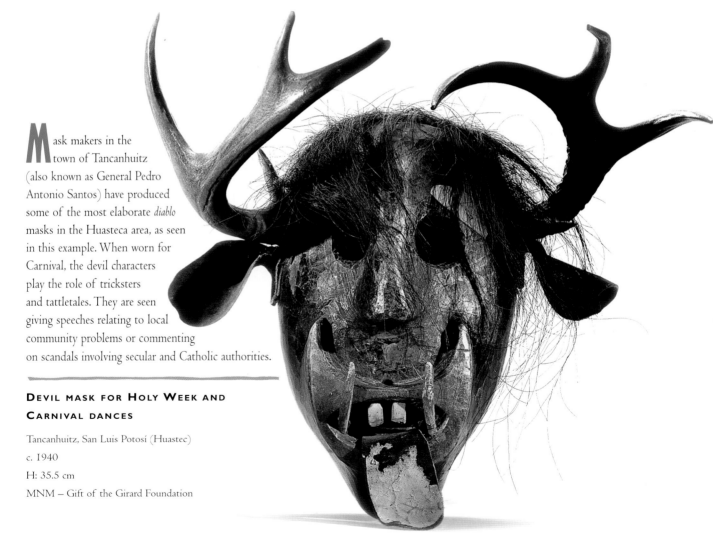

Mask makers in the town of Tancanhuitz (also known as General Pedro Antonio Santos) have produced some of the most elaborate *diablo* masks in the Huasteca area, as seen in this example. When worn for Carnival, the devil characters play the role of tricksters and tattletales. They are seen giving speeches relating to local community problems or commenting on scandals involving secular and Catholic authorities.

DEVIL MASK FOR HOLY WEEK AND CARNIVAL DANCES

Tancanhuitz, San Luis Potosí (Huastec)

c. 1940

H: 35.5 cm

MNM – Gift of the Girard Foundation

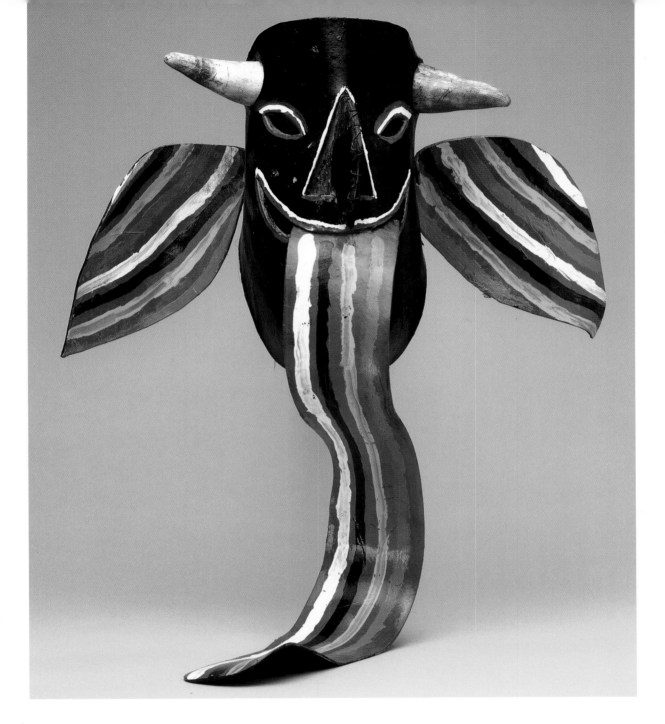

One of the Huastec dances performed for Carnival and Day of the Dead portrays wild Indians, known as *Comanches* or *Tastoanes*, who wear the distinctive style of mask shown here. The face is made of painted leather while the ears and long tongue are cut from tire inner tubes.

COMANCHE MASK FOR CARNIVAL AND DAY OF THE DEAD DANCES

San Vicente Tancuayalab, San Luis Potosí (Huastec)

1997

H: 57 cm (with tongue)

IFAF – Purchased from Sergio Roman Rodriguez

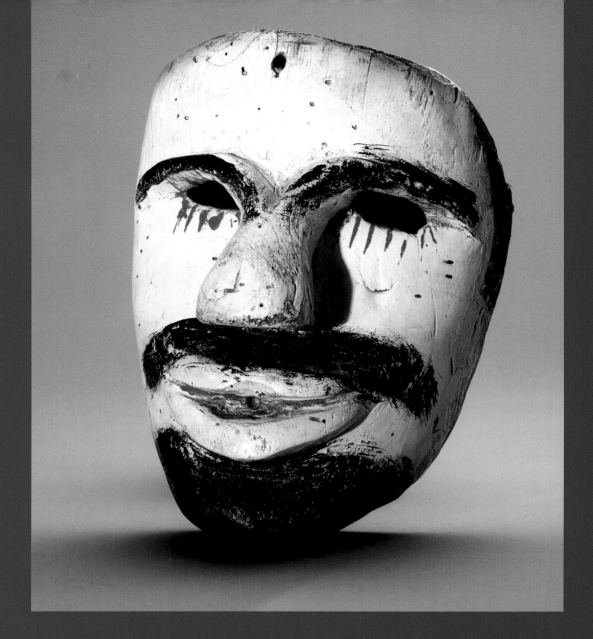

Masqueraders, known as *Xantolos* (supplicants), appear in Huastec communities during All Saints and All Souls Day observances on November 1 and 2. Viewed as ancestors from the community at large, they go from house to house asking for food left over from the recent harvest. As part of their begging performance, they simulate sexual acts with other ancestral spirits. All of their activities are intended to help promote a good agricultural season and harvest in the coming year. Some *Xantolo* masks are very small with simple carving while others are full size with crude features and bold painting, as seen here. A distinguishing aspect of all *Xantolo* masks is intentional distortion around the mouth.

XANTOLO MASK FOR DANCE OF THE XANTOLOS

Tiliche, San Luis Potosi (Huastec)

c. 1950

H: 20 cm

IFAF – Purchased from René Bustamante

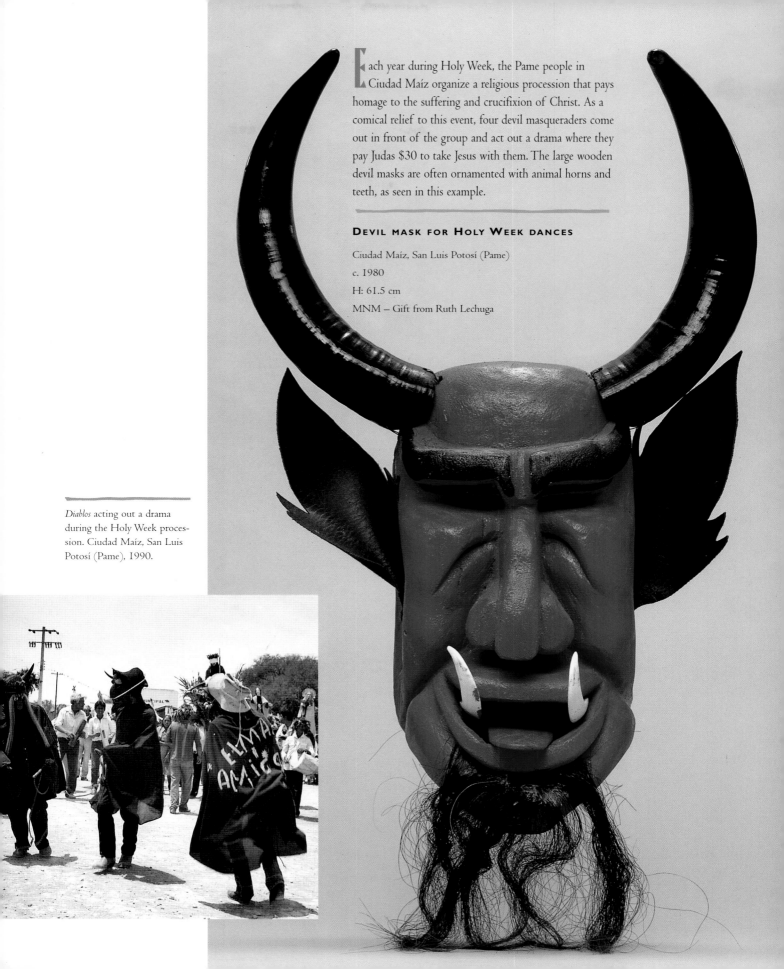

Each year during Holy Week, the Pame people in Ciudad Maíz organize a religious procession that pays homage to the suffering and crucifixion of Christ. As a comical relief to this event, four devil masqueraders come out in front of the group and act out a drama where they pay Judas $30 to take Jesus with them. The large wooden devil masks are often ornamented with animal horns and teeth, as seen in this example.

DEVIL MASK FOR HOLY WEEK DANCES

Ciudad Maíz, San Luis Potosí (Pame)
c. 1980
H: 61.5 cm
MNM – Gift from Ruth Lechuga

Diablos acting out a drama during the Holy Week procession. Ciudad Maíz, San Luis Potosí (Pame), 1990.

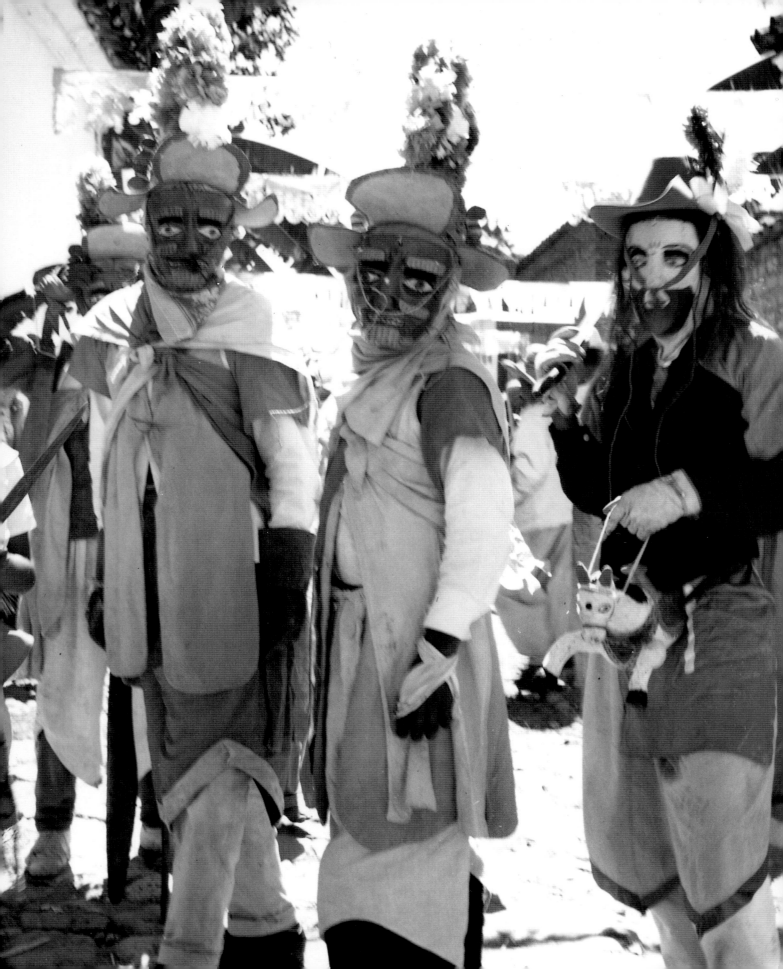

Guerrero

Guerrero has the most prolific masked festival traditions in Mexico, with a variety of dances and mask types. This is due to the large population of Nahua peoples spread throughout the northern and eastern sections of the state, along with smaller groups of Mixtec, Amuzgo, and Tlapanec. For the most part, the performances take place on saints' feast days and civic holidays.

A number of the dance dramas are local variations of the Moor and Christian pageant, where Santiago is often a featured character. The Moors wear a variety of headdress and mask styles, particularly in the villages south and east of Tixtla. Related to these are the conquest dances that tell the story of Cortés, Spanish soldiers, and priests conquering the Aztecs and other Mexican Indian groups. Other dances, such as *Tres Potencias* (Three Powers), *Siete Vicios* (Seven Vices), and *Los Ocho Locos* (The Eight Fools), grew out of morality plays introduced by Spanish missionaries, where a war between good and evil is acted out with masked characters. These types of performances are especially popular in the region around Tixtla and Mochitlán. Other performances focus primarily on *diablos*, who duel with one another or other people from the community. Taking a variety of forms, these dances are found around Tixtla and further east to Tlapa, as well as in towns around the city of Iguala in northern Guerrero. In Teloloapan, southeast of Iguala, the townspeople celebrate September 16—Independence Day—with the *Mojiganga de los Diablos* (Mummery of Devils), wherein townspeople, wearing extremely elaborate devil masks, compete with one another for prizes.

Many of the masked dances throughout the north and eastern sections of the state portray a form of the jaguar, or *tigre*, drama. In one, known as the *Tecuanes* (wild beast), the *tigre* attacks the local animals and, after much activity, is finally killed by a masked farmhand, called a *Rastrero* (Tracker). A related pageant features *Tlacololeros* who represent men clearing their cornfields and burning the brush. A threatening *tigre* is lurking nearby, but with the assistance of a dog it is hunted and killed. In the villages of Zitlala and Acatlán costumed man/jaguar figures come from different *barrios* to perform fierce fighting competitions said to be petitions for rain. Other types of animal dances are also performed in towns around the Tixtla region featuring a wide range of characters such as goats, monkeys, rabbits, and pigs.

The Dance of the *Pescado* (Fish) is popular in some Nahua communities, such as Mochitlán and Quechultenango, to promote good fishing in the rivers that run through the mountain valleys. Rather than portraying themselves, however, many of the masks represent the professional black-skinned fishermen from the coast. In some villages this performance is substituted by the Dance of the *Caiman* (Alligator), where dancers wear alligator and mermaid structures fastened to their waists. Another popular

◄ *Moro-Chinos* and Santiago taking a break from the Moor and Christian dance drama. Mochitlán, Guerrero (Nahua), 1962.

dance in the Mochitlán region is the *Viejos* or *Huehues* (Old Ones), which comically reminds the community of indigenous traditions and the heritage of past times. Related to this is *Los Manueles*, a comical pageant involving a village girl who is falsely betrothed to a bridegroom.

The Nahua village of Atzacoaloya, east of Tixtla, is known for a variety of lively masked pageants, including the Dance of the Snakes with *Negritos* wearing elegant clothing adorned with colorful ribbons. Their black papier-mâché masks come from a neighboring town. For the most part, Carnival is not a major festival in the Nahua communities of Guerrero, but the townspeople of Temalacatzingo, located north of Olinalá near the border with Puebla, do celebrate this occasion with maskers who parade and frolic with the crowds. Their wooden masks often have a lacquer finish that is a specialty of the region.

Tlapaneco peoples, living in towns around Mochitlán and further east, also masquerade, as seen in the *judíos* who appear during Holy Week in Zapotitlan Tablas wearing wooden masks with grimacing features. In the town of Tlacotepec, Tlapaneco men perform the *Danza de los Zopilotes* (Turkey Buzzards) wearing simple masks with long beaks made from either cardboard or pointed hat tops.

The Mixtec villages are primarily located in the southeastern corner of the state along the border with Oaxaca. Many of these communities also have masked dances, including versions of the *tigre* hunt drama performed for Carnival.

The *Teronsillo* pageant, in Metlatonoc, focuses on ranch life and features a *Negrito* cowboy in the cast of characters. The Mixtec village of Tototepec is known for the masked dance of the *ya-yashi*, or *Jícara* (gourd bowl), which includes the comical man and woman of the house and a variety of animals, such as the dog, wild boar, rooster, and parakeet.

The Amuzgo people also live in the southeastern corner of Guerrero and join the Mixtec in celebrating Carnival. In the village of Xochislahuaca they wear a variety of animal masks and carry around the *machomula*, an enormous horse made of wooden sticks. Some of the coastal towns of this region, such as Cuajiniculapa, have concentrated populations of black people (descendants of the African slaves) who wear striking devil masks as part of their Day of the Dead festivities.

Most communities in Guerrero have craftsmen who produce masks for the array of dances. The styles vary greatly from one artist to another, often making it difficult to classify a Guerrero mask. Some craftsmen, particularly in the towns of Iguala, Tixtla, and Chapa, also make masks for an outside commercial market. These are usually slicker and more fantastic than those used in the traditional context. Since the 1960s this commercial production has developed into a sizable industry in Guerrero, and due to the rising value of older masks, some craftsmen have intentionally made their pieces look older to entice unsuspecting buyers.

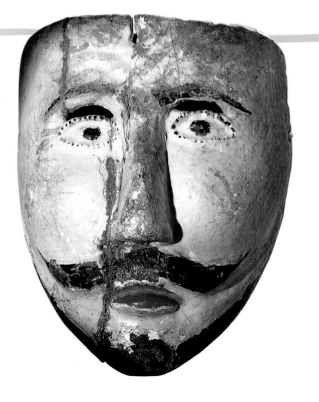

This is a good example of a Christian mask, characterized by fair skin color and simple mustache and beard. In this mask the lips have been painted red, which is not always the case for the Christian faces. At some point this mask was broken into two pieces, perhaps during one of the battle scenes with the Moors. Twine inserted through tiny holes pulled the pieces back together, allowing the mask to continue to be used.

CHRISTIAN MASK FOR MOOR AND CHRISTIAN DANCE DRAMA

Ajuchitlan, Guerrero (Nahua)

Early twentieth century

H: 19 cm

IFAF – Purchased from the Cordry collection

The style of Moor masks worn in Guerrero varies from town to town and from one time period to another, but many show the typical iconography of a Moor with fair skin, dark hair and beard, and red cheeks. In this example, the carving of the mask is quite crude, but the maker has created a wonderful expression through the long nose and simple painting around the eyes, cheeks, and chin.

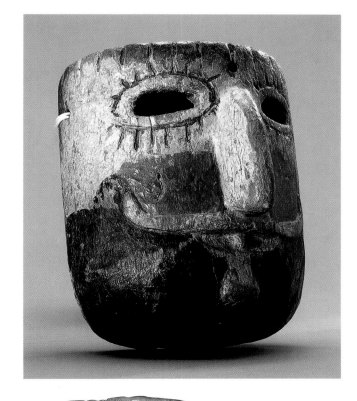

MOOR MASK FOR MOOR AND CHRISTIAN DANCE DRAMA

Los Sabinos, Guerrero (Nahua)
1950s
H: 17 cm
IFAF – Purchased from the Cordry collection

This is another style of Moor mask, popular among dancers in the region around Mochitlán and Tixtla. It is distinguished by the red skin color and protruding horizontal blocks across the eyebrows, cheeks, and sometimes the chin. Accompanying costumes often include a large headdress decorated with curled paper, giving the name of *Moro-Chino* (Curly Moor). When worn with another type of headdress, the character is called *Moro-Cabezon* (Big-Headed Moor).

MOOR MASK FOR MOOR AND CHRISTIAN DANCE DRAMA

Analco, Guerrero (Nahua)
c. 1965
H: 17 cm
MNM – Gift of Kathleen and Robert Kaupp

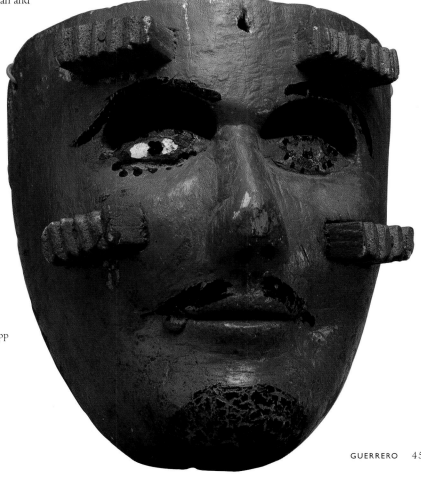

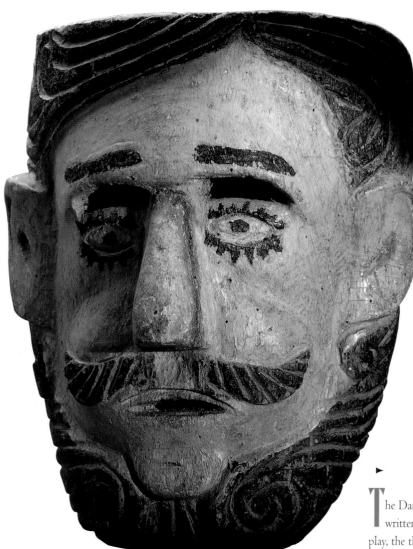

◄

The masked character of the Spanish conqueror Cortés is generally portrayed with abundant hair, including a mustache and beard. Here the mask maker has emphasized this even more through relief carving showing swirls in the dark fibers.

CORTÉS MASK FROM CONQUEST DANCE DRAMA

Teloloapan region, Guerrero (Nahua)

1950s–1960s

H: 22.5 cm

IFAF – Purchased from the Cordry collection

►

The Dance of the *Tres Potencias* is generally performed with a written text handed down from colonial times. As a morality play, the theme is a battle between good and evil, with various masked characters such as Christ, the Virgin, and the Soul fighting the Devil, Sin, and Death. The evil nature of death is well portrayed in this *Muerto* mask dating from the turn of the century. It was beautifully carved and painted with a high dome of leather on the crown.

MUERTO MASK FOR *TRES POTENCIAS* DANCE

Tixtla, Guerrero (Nahua)

Late nineteenth–early twentieth century

H: 29 cm

IFAF – Purchased from the Cordry collection

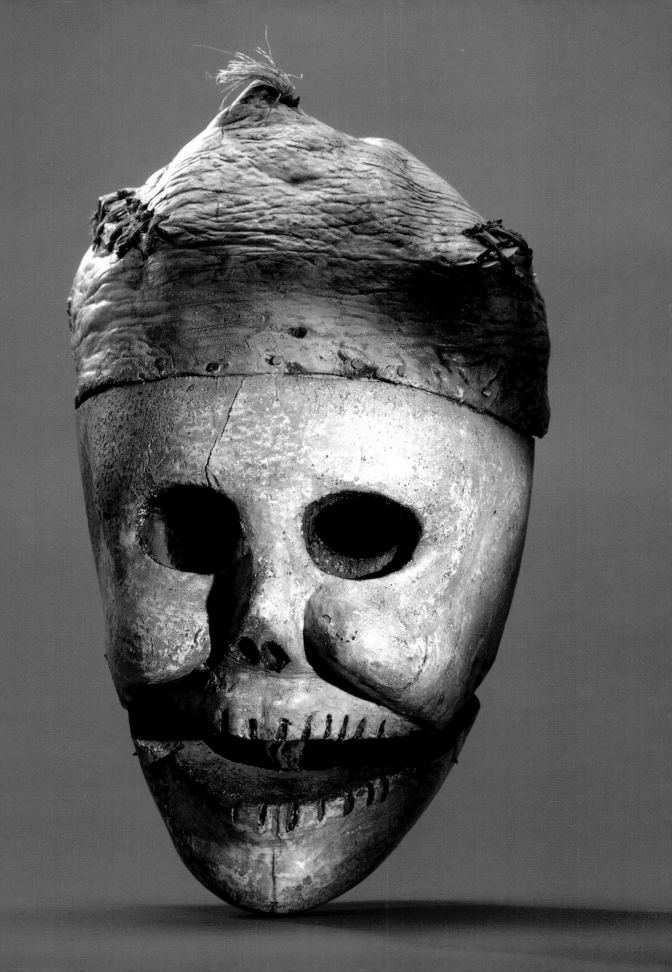

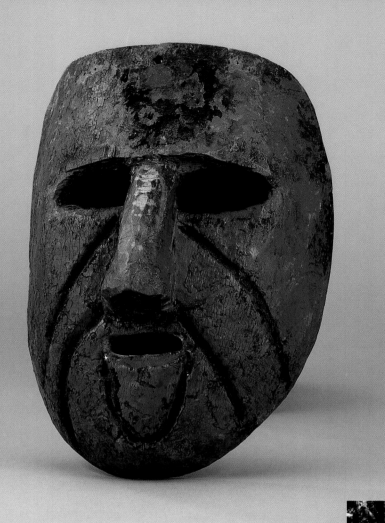

The humorous *Meco* dance portrays a group of "wild Indians" whose souls are fought over by an Indian priest (wearing red) and a Catholic priest (in white). *Meco* comes from the term *Chichimeca*, a name given to the fierce Indians who lived in northern Mexico at the time of the conquest. They wear red masks with black vertical lines, either painted or scarred into the face, as seen in this old piece. More recent *Meco* masks are decorated with black dots spread over the entire face. These masqueraders are also referred to as *Apaches*.

MECO MASK FOR MECO DANCE

Tlacotepec, Guerrero (Nahua)
Early twentieth century
H: 20 cm
IFAF – Purchased from the Cordry collection

Spanish and Indian "priests" trying to win the soul of the *Meco*, or "wild Indian," in the *Meco* dance drama. Mochitlán, Guerrero (Nahua), 1962.

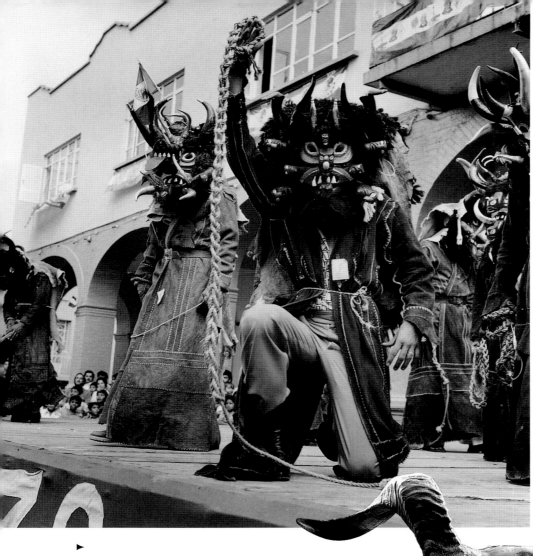

Devils performing for the competition of the *Mojiganga de los Diablos*. Teloloapan, Guerrero (Nahua), 1976.

▶

The *Mojiganga de los Diablos* (Mummery of Devils) takes place in the Nahua community of Teloloapan each year on September 16. Participants wear elaborate *Diablo* masks and costumes and promenade through the town competing with one another for prizes. Many of these masks have been made by Santiago Martinez Delgado, who lives in the neighboring town of Chapa. The example seen here features goat horns and a large mouth with fangs and moveable tongue, adding to the dramatic appearance. By the 1970s this style of mask was also being made for the outside collector market.

DIABLO MASK FOR *MOJIGANGA DE LOS DIABLOS*

Made by Santiago Martinez Delgado

Chapa, Guerrero (Nahua)

1960s

H: 38.2 c.

IFAF – Purchased from the Cordry collection

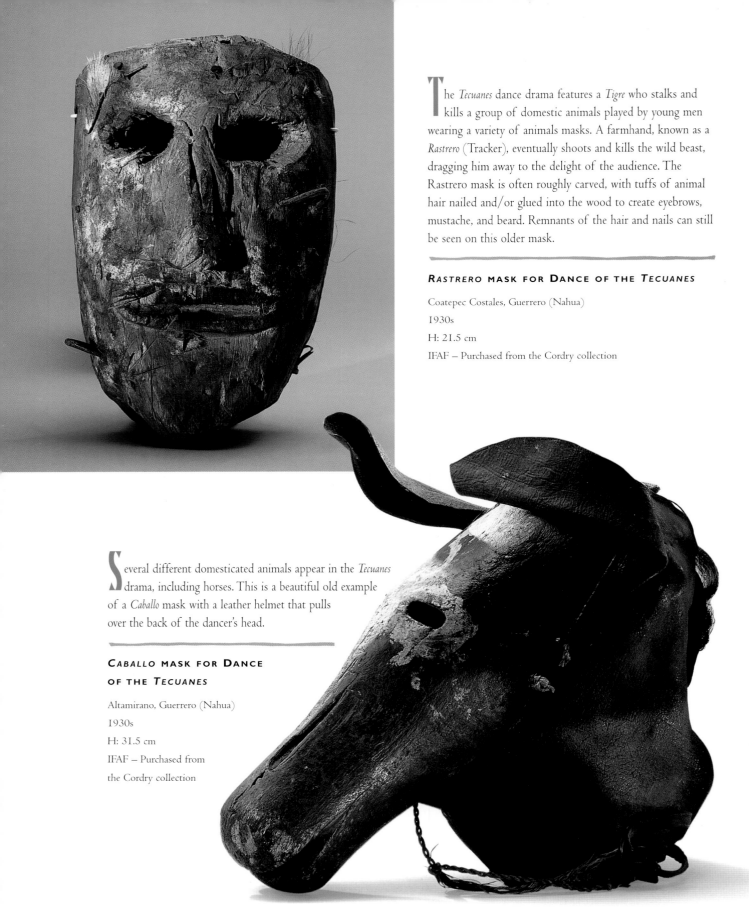

The *Tecuanes* dance drama features a *Tigre* who stalks and kills a group of domestic animals played by young men wearing a variety of animals masks. A farmhand, known as a *Rastrero* (Tracker), eventually shoots and kills the wild beast, dragging him away to the delight of the audience. The Rastrero mask is often roughly carved, with tuffs of animal hair nailed and/or glued into the wood to create eyebrows, mustache, and beard. Remnants of the hair and nails can still be seen on this older mask.

RASTRERO MASK FOR DANCE OF THE *TECUANES*

Coatepec Costales, Guerrero (Nahua)

1930s

H: 21.5 cm

IFAF – Purchased from the Cordry collection

Several different domesticated animals appear in the *Tecuanes* drama, including horses. This is a beautiful old example of a *Caballo* mask with a leather helmet that pulls over the back of the dancer's head.

CABALLO MASK FOR DANCE OF THE *TECUANES*

Altamirano, Guerrero (Nahua)

1930s

H: 31.5 cm

IFAF – Purchased from the Cordry collection

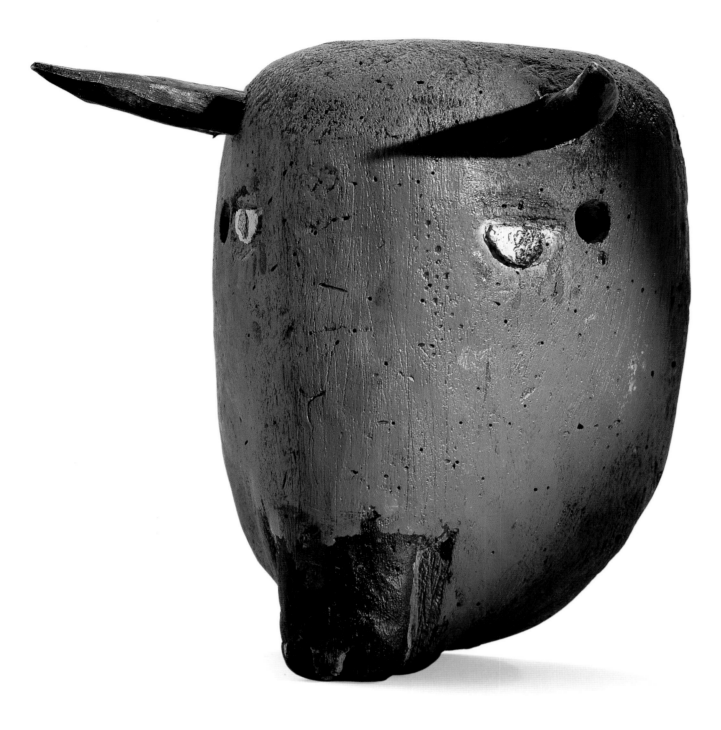

Another domesticated animal that often appears in the *Tecuanes* dance is the *Toro*, or bull. Here the mask maker has portrayed him as a sweet, innocent victim to be pursued by the *Tigre*.

TORO MASK FOR DANCE OF THE *TECUANES*

Guerrero (Nahua)

c. 1960

H: 22.5 cm

MNM – Gift of the Girard Foundation

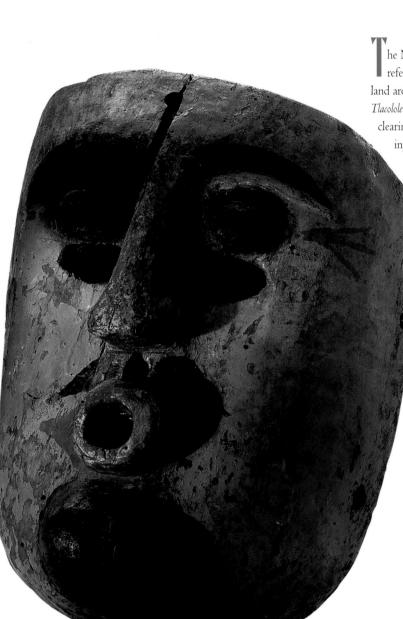

The Nahua word *Tlacol* (twisted) refers to the circular cultivation of land around the terrain of a hill. The *Tlacololeros* portray farmers who are clearing their fields while a threatening *Tigre* lurks nearby. The farmer masks vary from one village to another, but in this example the carver has created a dynamic facial expression with the circular mouth.

TLACOLOLERO MASK FOR TLACOLOLERO DANCE DRAMA

Guerrero (Nahua)

c. 1940

H: 27 cm

MNM – Gift of the Girard Foundation

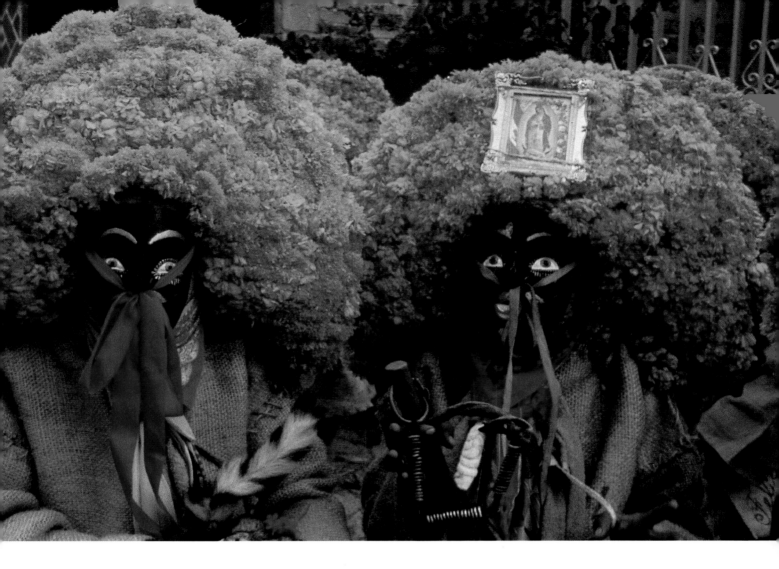

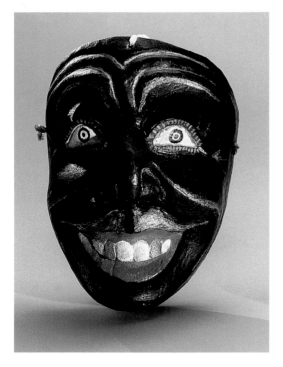

This is a good example of the *Tlacololero* masks worn in Chichihualco, where they vary in color from black to brown to red. Here the farmers are noted for their large circular headdresses made of woven pine and decorated with marigolds.

TLACOLOLERO MASK FOR THE *TLACOLOLERO* DANCE DRAMA

Chichihualco, Guerrero (Nahua)

c. 1960

H: 23.8 cm

MNM – Gift of the Girard Foundation

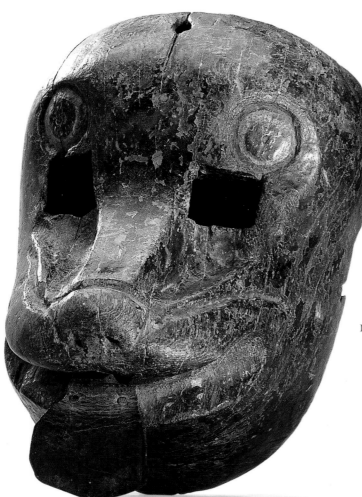

The carver of this mask captured the expression of the loyal dog, *Maravilla*, who assists his masters in tracking down the *Tigre*. Masks such as this are loved by the whole community and are used year after year, eventually acquiring a well-worn patina.

MARAVILLA DOG MASK FOR *TLACOLOLERO* DANCE DRAMA

Guerrero (Nahua)

c. 1930

H: 22.5 cm

IFAF – Purchased from the Cordry collection

The *Tigre* masks of Guerrero also vary in style from one town to another. This example from El Limón is simply carved in dense copal wood. Although the painting is somewhat crude, the artist has created a mischievous expression in keeping with the devious character of the *Tigre* in this dance drama.

TIGRE MASK FOR *TLACOLOLERO* DANCE DRAMA

Made by Bartolo Suastigue

El Limón, Guerrero (Nahua)

c. 1975

H: 31.9 cm

IFAF – Purchased from Bartolo Suastigue

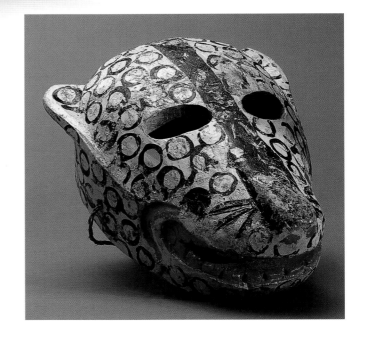

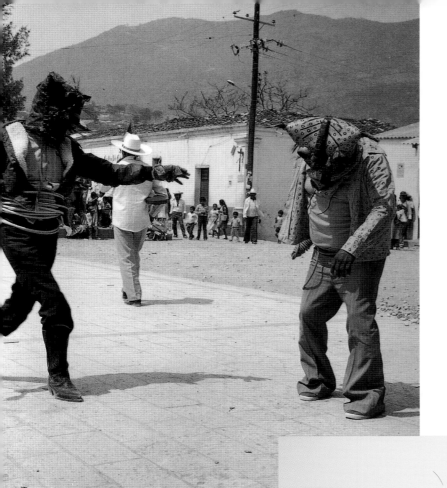

Jaguars in fierce combat during the celebration for the feast of the Holy Cross. Zitlala, Guerrero (Nahua), 1987.

Each year on May 3, 4, and 5, the community of Zitlala celebrates the feast day of the Holy Cross. As part of the activities, men from different *barrios* put on jaguar costumes and carry out fierce fighting competitions that involve beating each other over the head with knotted rope. Although this is very rugged for the participants, the fighting is considered a crucial aspect in petitioning the deities for rain during the spring planting season. The impressive masks are made in leather and worn over the entire head to protect the wearer from injury. The leather is painted green or yellow, depending on which *barrio* of town the participant is from.

JAGUAR MASK FOR COMBAT DRAMA

Zitlala, Guerrero (Nahua)

Early twentieth century

H: 28 cm

IFAF – Purchased from the Cordry collection

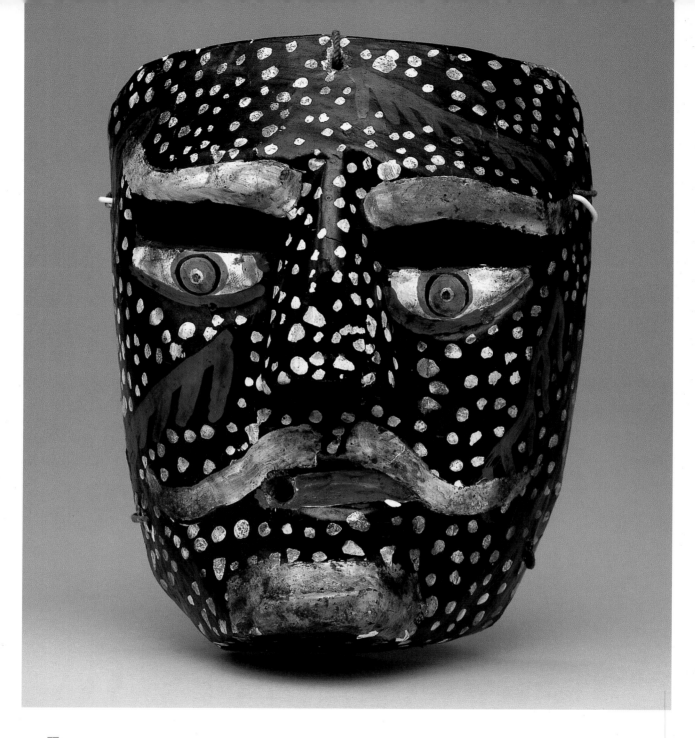

Performers in the *Pescado* (Fish) dances generally wear black masks, portraying the skilled Negro fishermen (*Costeños*) who live on the Guerrero coast. As in this example, a hole is usually cut through the lip of the mask to hold a cigarette, since the *Costeños* are avid cigarette smokers.

PESCADOR* MASK FOR DANCE OF THE *PESCADO

Made by Jesús Blanco

Quechultenango, Guerrero (Nahua)

c. 1975

H: 18.5 cm

IFAF – Purchased from Jesús Blanco

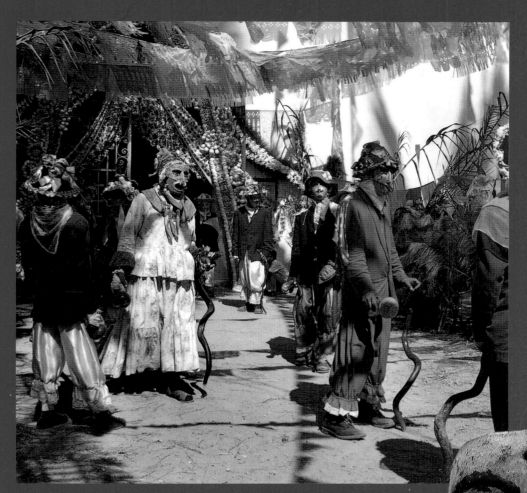

Masqueraders in the *Manueles* dance drama. Mochitlán, Guerrero (Nahua), 1976.

This type of *Vieja* mask is worn by a man who comically acts out the antics of an old woman in the community. It may also be worn in the *Manueles* drama, to portray a mother who is upset with her daughter's fiancé for breaking their marriage engagement.

VIEJA MASK FOR *VIEJO* AND *MANUELES* DANCES

Tonantzintla, Guerrero (Nahua)

c. 1950

H: 20.5 cm

MNM – Gift of Kathleen and Robert Kaupp

The Mixtec peoples along the southern coastal region of Guerrero and in the neighboring state of Oaxaca also perform *Tigre* dramas relating to the agricultural cycle. The mask shown here was designed to be worn with the dancer looking out through the opening of the mouth, which once had sharp teeth made of cactus needles, porcupine quills, or wooden dowels. The depressions for the eyes were probably decorated with small mirrors that caught the light as the dancer moved.

TIGRE MASK FOR *TIGRE* DANCE DRAMA

Chalpatlahua, Guerrero (Mixtec)

c. 1950

L: 44.2 cm

IFAF – Purchased from the Cordry collection

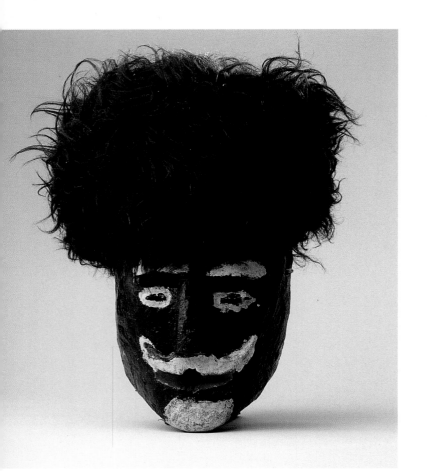

Another masked drama performed by the Mixtec people in Guerrero is the *Teronsillo* dance that features African *Vaqueros*, or Cowboys, from the coastal area. The drama takes place in a hacienda and ends with the killing and butchering of a bull. A hole has been cut in the center of the lips in this *Negrito* mask so that the dancer can smoke a cigarette in imitation of the black cowboys.

NEGRITO MASK FOR *TERONSILLO* DANCE

Metlatonoc, Guerrero (Mixtec)

c. 1960

H: 35 cm

IFAF – Purchased from the Cordry collection

Oaxaca

The state of Oaxaca is rich in masked dances due to the large number of ethnic groups who continue to carry out their festival traditions. The Mixtec, who live in different geographical regions throughout the western part of the state, are particularly known for their colorful masked dramas. In the Mixtec coastal area (called the Costa Chica), Carnival is one of the most important celebrations, when townspeople perform a version of the *tigre* drama, known as *Tejorones*. Each village, such as Pinotepa Nacional, Huaspaltepec, and San Juan Colorado, has its own interpretation of this pageant, with performers wearing a variety of well-carved masks. These include the *Tejorones*, who wear small face coverings with European features, very realistic *Negritos*, the fanciful *tigre*, and a wide range of other animals.

The town of Juxtlahuaca, in the Mixtec highland region, is also known for a variety of dances performed for Carnival and the feast day of Santiago. These include a range of masked characters from the *Chareos* and *Mahomas* (Moor and Christian drama) to the *Rubios* (humorous hunting drama) to the *Machos* (who perform a version of "Beauty and the Beast"). Fanciful *diablos* and other clowns also interact with the crowds. Some of the most interesting masked characters, however, are the *Chilolos*, who perform a combative line dance wearing red masks with many abstract features thought to derive from pre-Hispanic Mixtec masking traditions. Dancers in the neighboring village of Yanhuitlán, wear a different style of *Chilolo* mask crudely carved in wood, coarsely painted, and frequently decorated with eyes of wax and glass marble.

The Zapotec peoples in the central valley of Oaxaca are probably best known for their version of the conquest drama, called the *Danza de Pluma*, but with the exception of a few *Negritos* the performers don't wear masks. One of the most important masked dances in this region is *Los Jardineros*, where actors wearing wax masks play out a parody on court life. The *Dance of the Viejos* is performed in July and August in the central-valley Mixtec town of Cuilapan, where participants often wear crude masks portraying animals.

Chatino people in Juguila, Yaitepec, and other towns in southwestern Oaxaca perform a version of the *Tejorones* drama on November 4 just after their Day of the Dead observances. Wearing a variety of masks, the performers go from house to house expelling the spirits of the dead ones and simulating sexual acts among the ancestors as part of the fun.

As seen in the neighboring region of Guerrero, African descendants living in La Estancia Grande and other villages along the southwestern coast do performances for Day of the Dead that feature *diablos* running through the streets. Their masks tend to be more ephemeral, made from cardboard or hide, and often thrown into the ocean after the festivities are over.

In the Sierra de Juárez, to the east of the central valley, Zapotec and Mixe peoples perform masked dances during the Christmas/New Year season and for various saints' feast

days. Many of these feature *Negritos* wearing elegant clothing and dark brown masks with very natural features. Another type of *Negrito* is also found in the Sierra de Juárez who wears a much cruder black mask with a snout and upturned tusks. Some of the festivals also include *Viejos* who act as comedians while policing the crowd. Their masks range from those with fair skin and European faces to those with darker skin and grotesque features.

Along the Tehuantepec peninsula, in the southeastern section of Oaxaca, the Huave people carry out a number of masked dramas as well. One of the most famous is the *Danza de la Serpiente* performed for Corpus Christi and the feast day of San Mateo, during which a wooden serpent mask is worn on the back of the dancer. Chontal people in this region perform a version of the Moor and Christian drama for the feast day of San Pedro.

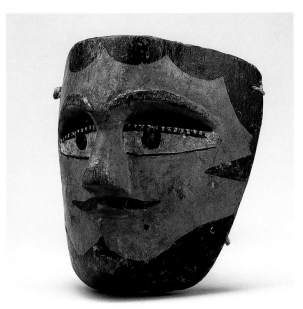

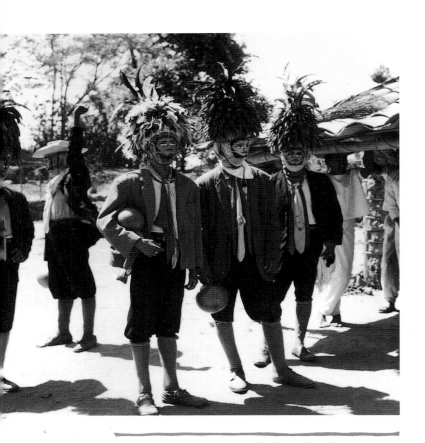

Tejorones wearing small masks and tall, feathered headdresses during the Carnival performances of the *Tejorones* drama. Huaspaltepec, Oaxaca (Mixtec), 1966.

Groups of male masqueraders, known as *Tejorones*, are key actors in the *Tejorones* dance drama. As seen here, their masks are very small, creating an illusion that the dancers are much taller than they actually are. The masks are worn on the upper part of the face, with scarves wrapped around to conceal the mouth and chin. The *Tejorones* in the village of Huaspaltepec often wear a tall feather headdress, further adding to the height of the character.

TEJORÓN MASK FOR THE *TEJORONES* DANCE DRAMA

Huaspaltepec, Oaxaca (Coastal Mixtec)
c. 1940
H: 12.3 cm
Spanish Colonial Arts Society — Gift of James Economos

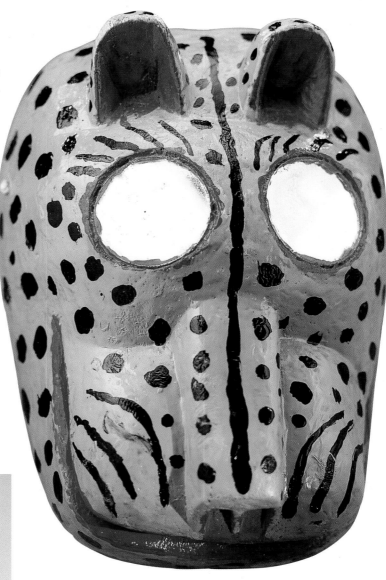

Much of the action in the *Tejorones* drama revolves around the *Tigre*, who tries to kill the other animals and disturb the community. In this example, the *Tigre* mask is worn on the top of the head, with a scarf covering most of the dancer's face.

TIGRE MASK FOR THE *TEJORONES* DANCE DRAMA

Costa Chica region, Oaxaca (Coastal Mixtec)

c. 1960

H: 21.3 cm

MNM – Gift of the Girard Foundation

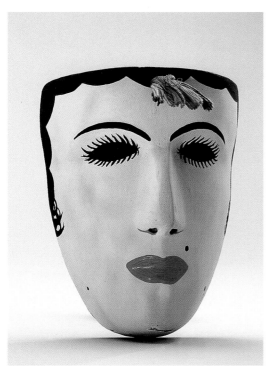

María *Candelaria* is an important female character of the *Tejorones* drama. Her mask is very small, with the lower part of the dancer's face covered in scarves. Although repainted by a member of the Lopez family in the early 1980s, the back of this beautiful mask shows decades of use, indicating it was carved earlier in the century.

MARÍA CANDELARIA MASK FOR THE *TEJORONES* DANCE DRAMA

Pinotepa Nacional, Oaxaca (Coastal Mixtec)

Lopez Family

c. 1940

H: 16.5 cm

IFAF – Purchased from the Lopez family

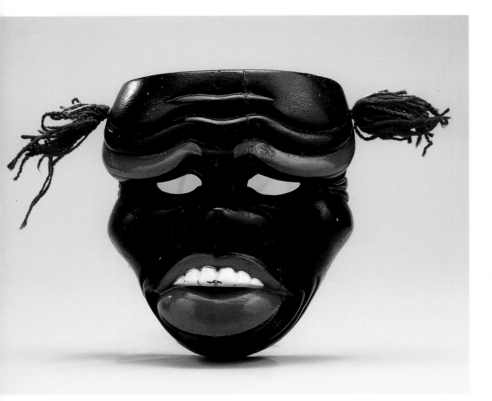

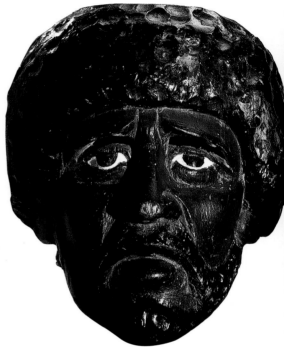

African slaves were brought into this coastal region of Oaxaca during colonial times, and their descendants continue to live in communities here today. The Mixtec like to masquerade as *Negritos*, and they appear in many of the *Tejorones* performances. Some of these masks, such as those made by Erineo Lopez Ortiz and his deceased brother Filiberto Lopez, exaggerate the African facial features, as seen in this piece.

NEGRITO MASK FOR THE *TEJORONES* DANCE DRAMA

Made by Erineo Lopez Ortiz

Pinotepa Nacional, Oaxaca (Coastal Mixtec)

c. 1975

H: 17.8 cm

IFAF – Purchased from Erineo Lopez Ortiz

This *Negrito* mask was made by another master carver in the region, Iscidrio Vargas. It was beautifully carved in the likeness of a known Afro-Mixtec man living in the area. An inscription on the inside of the mask—*Los Huapachosos*—probably refers to a musical group the masquerader played in.

NEGRITO MASK FOR *TEJORONES* DANCE DRAMA

Made by Iscidrio Vargas

Mechoacán, Oaxaca (Coastal Mixtec)

c.1986

H: 26.5 cm

MNM – Gift of Robin and Barbara Cleaver

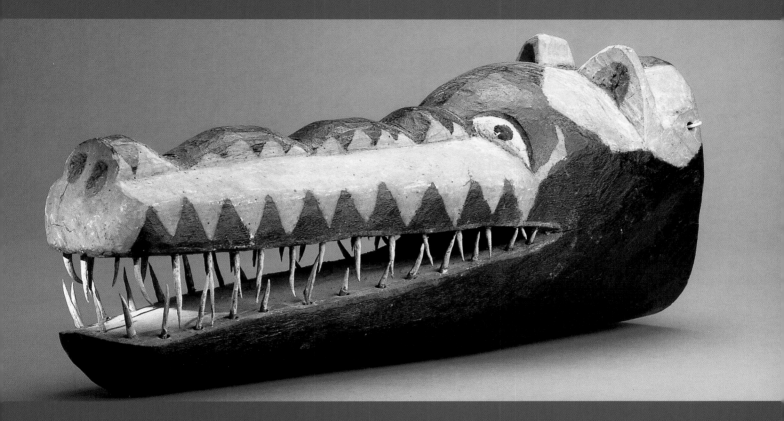

Alligators also appear in the *Tejorones* drama wearing elongated masks with sharp teeth made from cactus thorns, as seen in this example. The mask is worn over the dancer's face, creating a challenge to navigation.

ALLIGATOR MASK FOR THE *TEJORONES* DANCE DRAMA

San Pedro Siniyuri, Oaxaca (Coastal Mixtec)

c. 1970

L: 44 cm

IFAF – Purchased from the Cordry collection

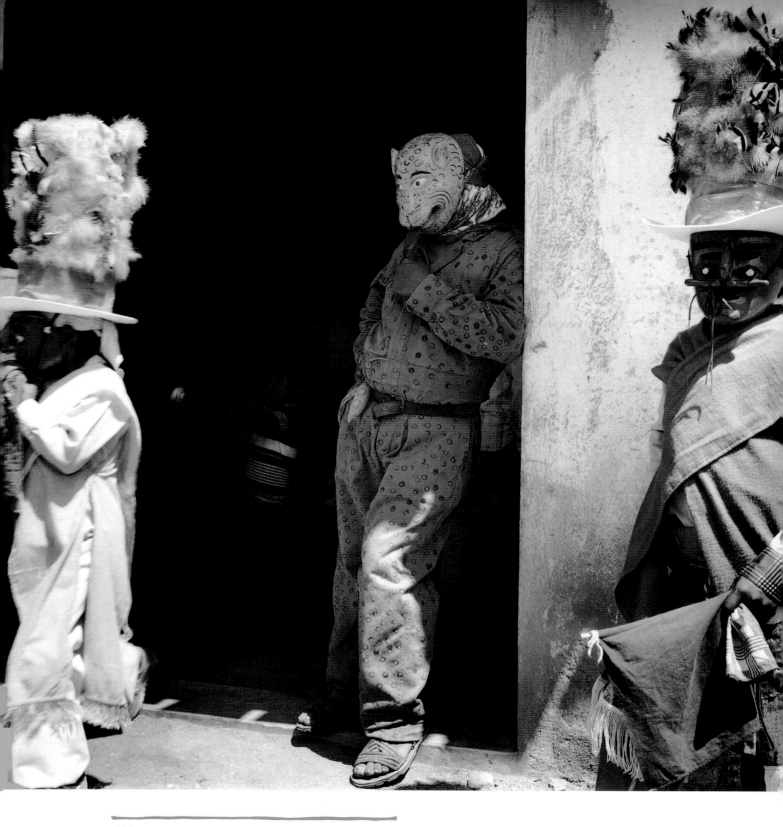

Chilolo and *Tigre* masqueraders taking a break from dancing during the Carnival celebrations. Juxtlahuaca, Oaxaca (Mixtec), 1981.

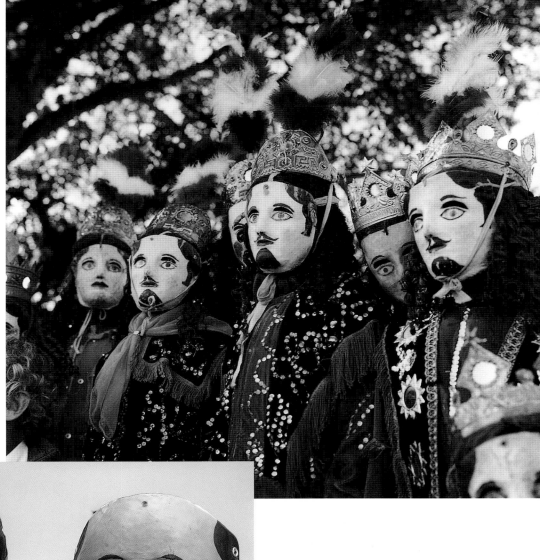

Los Jardineros pageant with the king, queen, and royal court. San Bartolo Coyotepec, Oaxaca (Zapotec), 1977.

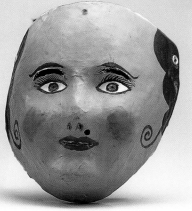

L os *Jardineros* is a popular dance drama performed in San Bartolo Coyotepec and other Zapotec villages in the central valley of Oaxaca. The main characters are the king and queen and their respective entourage. Their masks are made of molded wax painted with facial coloring.

KING AND QUEEN MASKS FOR *LOS JARDINEROS* DANCE DRAMA

San Bartolo Coyotepec, Oaxaca (Zapotec)

1983

H: 19 cm (left)

IFAF – Purchased from Victor Fosado

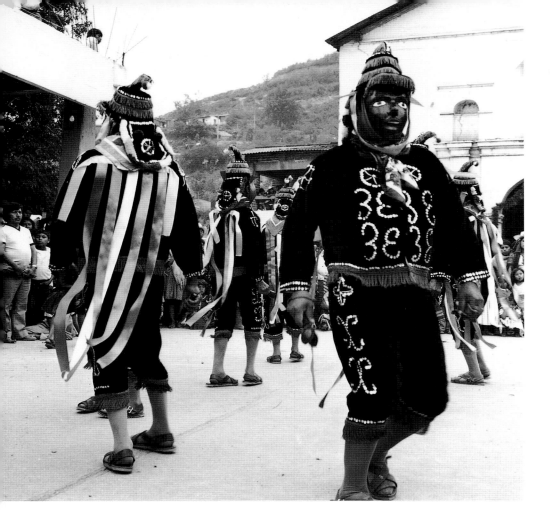

Black-faced masqueraders in some villages of the Sierra de Juárez are known either as *Cubanos* or *Mulatos*. They wear elegant, richly decorated clothing and perform in a calm and dignified manner. Some of the older *Cubano* masks from this region are distinguished by fine, delicate features and a dark café color, as seen in this example from the early twentieth century.

CUBANO, OR *MULATO*, MASK FOR FEAST DAY DANCES

Santiago Choápan, Sierra de Juárez, Oaxaca (Zapotec/Mixe)

Early twentieth century

H: 14.5 cm

IFAF – Purchased from the Cordry collection

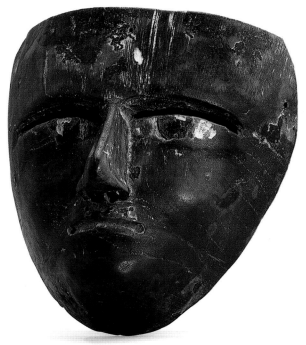

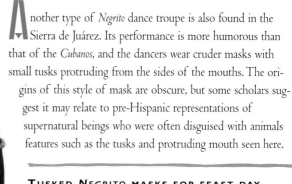

Another type of *Negrito* dance troupe is also found in the Sierra de Juárez. Its performance is more humorous than that of the *Cubanos*, and the dancers wear cruder masks with small tusks protruding from the sides of the mouths. The origins of this style of mask are obscure, but some scholars suggest it may relate to pre-Hispanic representations of supernatural beings who were often disguised with animals features such as the tusks and protruding mouth seen here.

TUSKED *NEGRITO* MASKS FOR FEAST DAY DANCES

Sierra de Juárez, Oaxaca (Zapotec and Mixe)

c. 1955

H: 17.5 cm (left)

IFAF – Purchased from Barbara and Robin Cleaver

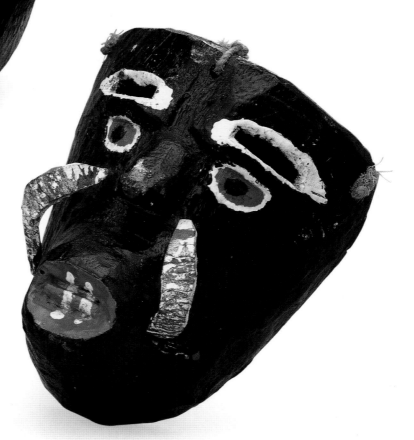

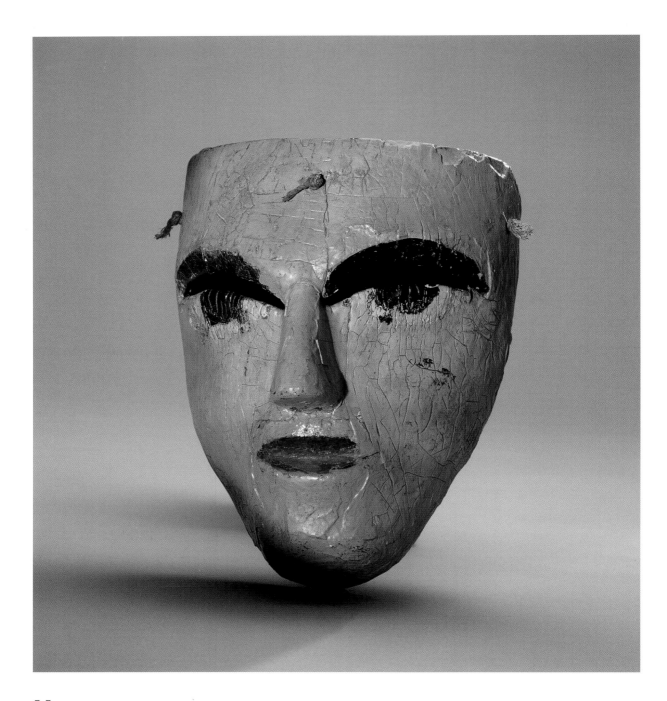

Viejos also perform for the various festivals in the Sierra de Juárez, usually appearing alone or in small groups. For the most part they act as comedians, humorously interacting with the other dancers and with the crowd. Their masks vary in style, from those with dark skin and grotesque features to others that are finely carved and portray fair-skinned European faces, as seen in this example.

VIEJO MASK FOR FEAST DAY DANCES

P. Vicente, Sierra de Juárez, Oaxaca (Zapotec/Mixe)

Early twentieth century

H: 16.5 cm

MNM – Gift of Michael Robins

Mexico State and Federal District

Although the Federal District of Mexico is noted for its dense population and industrial complexes, the state of Mexico that surrounds the capital is largely agricultural. Here there are groups of Nahua peoples dispersed throughout mestizo towns in the central and eastern sections of the state and a concentration of Mazahua and Otomí in the west and northwestern parts.

This whole region is known for its Moor and Christian dramas, performed in many *barrios*, towns, and villages for their saints' feast days. The older Moor and Christian masks of this state are generally well carved, and many have a hinged chin that moves when the actor speaks. Variations on this drama, such as *Los Doce Pares de Francia* (Twelve Pairs of France), are performed in towns throughout the state. Moor masks worn for this dance are often distinguished by accentuated markings around the eyes. In the town of San Martín de las Pirámides, near the pre-Columbian site of Teotihuacan, villagers perform a dance of Santiago, who appears wearing a fiberglass mask and aluminum helmet. He battles with the *Archareos* (Archers), whose masks are made from molded and painted felt, with a large pelt of goat or sheep fur surrounding it. Another type of battle drama, reenacting the *Cinco de Mayo* fight between the French and Mexicans, is acted out in Nexquipayac, Molino de Flores, Acolman, and other towns in the northeastern section of the state.

Pre-Lenten Carnival is also celebrated in many areas throughout the region, with masked performances relating to hacienda life of the colonial era. Underlying much of the action are petitions for rain and fertility of the crops. Some of the most realistic masks worn in these Carnival dramas come from the town of Santa María Astahuacán, now a suburb of Mexico City, where two generations of the Castillo family have produced a distinctive type of molded wax mask that portrays white-faced old men, cowboys, and hacienda owners. In many villages around the city of Texcoco, in the northeastern part of the state, Carnival participants wearing these wax masks dress as *Catrines*, or Dandies, and burlesque the life-style of the wealthy hacienda owners of the nine-

teenth century. Open umbrellas are part of the costume but also serve to petition the gods for rain during the springtime planting season.

In Nexquipayac, the villagers perform a humorous portrayal of a bullfight at a colonial hacienda that involves many characters but most not wearing masks. An exception is a group of *Viudas* (Widows) who dance brazenly with other men wearing crude masks made of plaster covered with fabric or shiny paper. Alongside this drama is another comical pageant focusing on the cruelty of the Catholic clergy during colonial times. Among the characters are altar boys who wear an interesting mask made of molded fabric that is gessoed and whitewashed. Women characters in this drama wear sewn fabric masks and rock a small doll in their arms as a symbol of fertility and hopes for a good agricultural season.

A very realistic drama of hacienda life is found in the town of Capulhuac, in the southwestern part of the state, that includes a variety of male and female masked characters. Among these are *Negritos*, who guide teams of real oxen around a field and wear simple papier-mâché masks painted black with slits for the eyes and mouth.

The town of Metepec, in the western part of the state near Toluca, is a famous pottery-producing village that is also dependent on agriculture. The May 15 feast day for their patron saint, San Ysidro Labrador, is the occasion for a large celebration, involving a dance called *de los Locos* (of the Fools). The main actors, *los locos*, wear masks traditionally made of clay, although today many of the men have switched to commercial rubber masks bought in local stores.

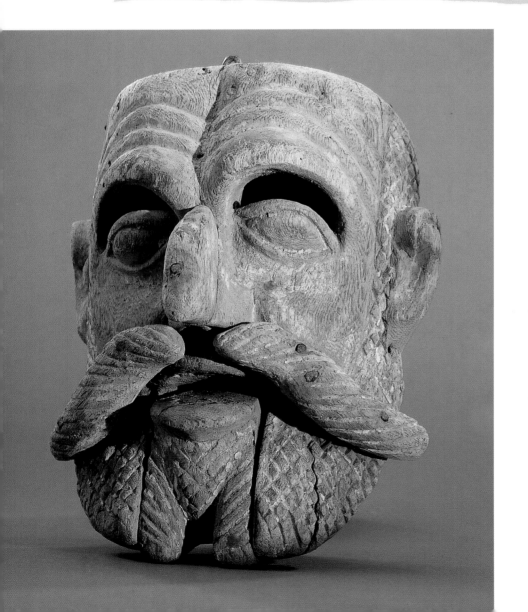

Although stripped of its paint, this is a beautiful old mask created in a style traditionally found in the state of Mexico. It is characterized by fine carving in the eyes, ears, facial details, and texture of the mustache and beard. The top of the nose and mustache were carved separately and attached, adding to the realistic shape of the face. The chin and lower lip are a separate hinged piece, allowing the dancer to move the mouth when he speaks.

MASK FOR THE MOOR AND CHRISTIAN DANCE DRAMA

Mexico State (Mestizo)
Early twentieth century
H: 25 cm
IFAF – Purchased from the Cordry collection

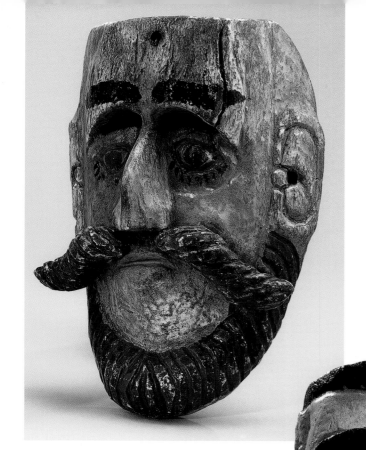

This is a style of Moor mask once used in the town of El Anate, located in the western part of Mexico State. The garish painting around the eyes and cheeks is a classic portrayal of the exotic Moor character.

MOOR MASK FOR MOOR AND CHRISTIAN DANCE DRAMA

El Anate, Mexico State (Mestizo)
1950s
H: 25.5 cm
IFAF – Purchased from the Cordry collection

Moor and Christian pageants are often carried out in small *rancheros* (ranches) in the Tequisquiapan region west of Mexico City. Here the Moor and Christian masks are very similar, with the costume and headdress of the performer defining his role. When this mask was collected in Salinas, it had been worn by a Moor. It was constructed with a hinged section for the beard that added to the dynamic performance of the character.

MOOR MASK FOR MOOR AND CHRISTIAN DANCE DRAMA

Salinas, Mexico State (Mestizo)
1940s
H: 29 cm
IFAF – Purchased from René Bustamante

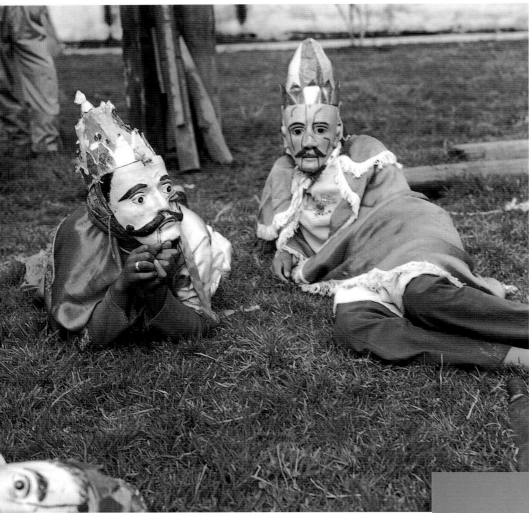

Moros taking a break from the Doce Pares de Francia dance drama. Mexicalzingo, Mexico (Mestizo), 1970.

In the Twelve Pairs of France drama, King Charlemagne and his troops fight a Christian battle against the Moors. The Moor masks are often distinguished by accentuated painting around the eyes, and each of the pagan characters wears a different style of headdress to identify his role. This mask portrays the "King Moor" who wears a crown. It comes from the town of Contepec, located in the west-central section of the state, near the border with Michoacán.

KING MOOR MASK FOR *LOS DOCE PARES DE FRANCIA* DANCE DRAMA

Contepec, Mexico State (Mestizo)
1940s
H: 42 cm
IFAF – Purchased from René Bustamante

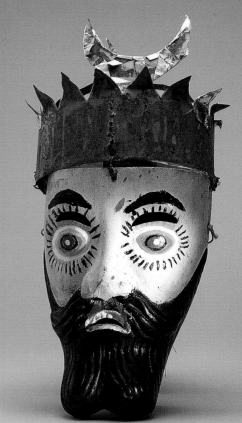

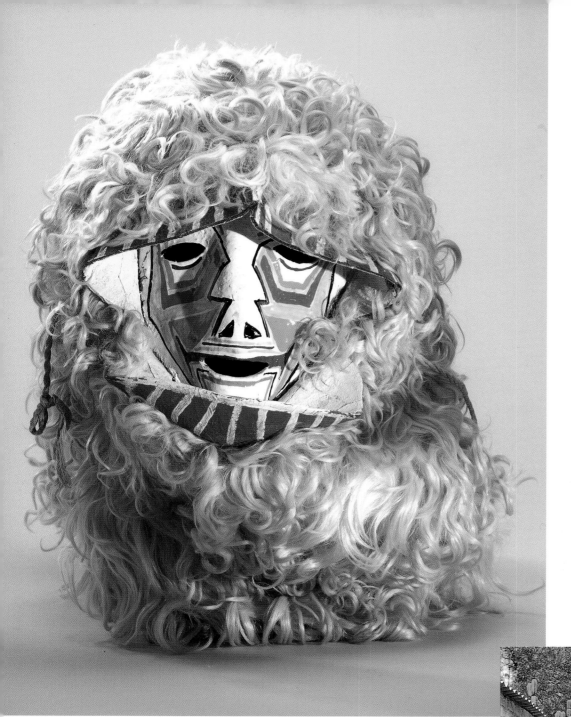

ARCHAERO MASK
FOR SANTIAGO
DANCE

Made by
Juan Gomez Alcivar
San Martín de las
Pirámides, Mexico
State (Mestizo)
1995
H: 49 cm
(with sheepskin)
MNM – Purchased
from Juan Gomez
Alcivar

A group of *Archaeros*
from the Santiago
dance drama per-
formed for the patron
saint feast day. San
Martín de las
Pirámides, Mexico
(Mestizo), c. 1980.

▲ **M**ask maker Juan Gomez Alcivar utilizes the technique of forming a felt mask over a ceramic mold. Bands of folded leather are attached to the upper and lower parts of the face; the whole mask is then painted in a white background with brightly colored patterns. A large sheepskin pelt is attached, completely covering the dancer's head and shoulders. The *Archaeros*, or Archers, come out as a group led by Pontius Pilate and battle with Santiago and his assistant. This dance drama is performed each year in celebration of the feast day of San Martín on April 13.

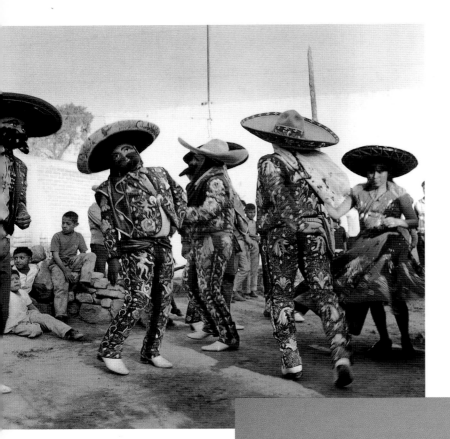

Charros enjoying the Carnival dances.
Atenco, Mexico (Mestizo), 1972.

In a small suburb of Mexico City, Delfino Castillo Alonso carries on a tradition passed down from his grandfather of making wax masks formed over plaster molds. This technique allows for very realistic shaping of the facial features, further enhanced with elaborate painting around the eyes. The addition of eyebrows, mustaches, and beards made from synthetic fibers allows Delfino to create different characters, such as the Old Man and Country Gentleman portrayed in these examples. The masks are primarily worn by Carnival masqueraders in small towns around Mexico City and in the eastern part of Mexico State.

VIEJO AND *CHARRO* MASKS FOR CARNIVAL DANCES

Made by Delfino Castillo Alonso

Santa María Astahuacán, Federal District (Mestizo)

1997

H: 27 cm (tallest on right)

MNM – Purchased from Delfino Castillo Alonso

Tlaxcala

Tlaxcala is known particularly for its colorful Carnival celebrations carried out in both Nahua and Otomí Indian communities. As seen in the neighboring state of Mexico, the masqueraders here generally portray and make fun of wealthy Europeans who settled in this region during the colonial era. Underlying this, however, are petitions for rain and fertility. The most common type of dance performed in Amaxac de Guerrero and other villages north of the capital city of Tlaxcala is the *Catrines*, or Dandies. These masqueraders wear a tuxedo, top hat, and gloves along with a wide red or embroidered band around their waist. They also carry a large, open umbrella that symbolizes the need for rain in the dry season.

In villages south of Tlaxcala city, such as Papalotla, Tepeyanco, and Mazotecochco, performers of the dance of the *Paragüeros* (those whose headdresses resemble umbrellas) or *Charros* (Spanish country gentlemen) wear elegant suits,

CENTRAL REGION

leather chaps, elaborately sequined capes, and large plumed hats. They carry long whips that make the cracking sound of thunder to encourage the deities to bring rain. The whips are also referred to as *cuebras*, or snakes, symbolic of water. In these villages female characters are still portrayed by masked men who dance with the *Charros* and interact with the crowd. At a certain point in the performance, they present a doll to the audience as a symbol of fertility.

Tlaxcalan Carnival masks are quite realistic, portraying Caucasians with the appearance of actual human skin. Some nineteenth-century examples were made from leather but most of the masks worn today are produced by *santeros*, or saint makers, who utilize their carving and painting skills to create very sophisticated face coverings. These are further enhanced with glass eyes that sometimes have closing eyelids and false eyelashes.

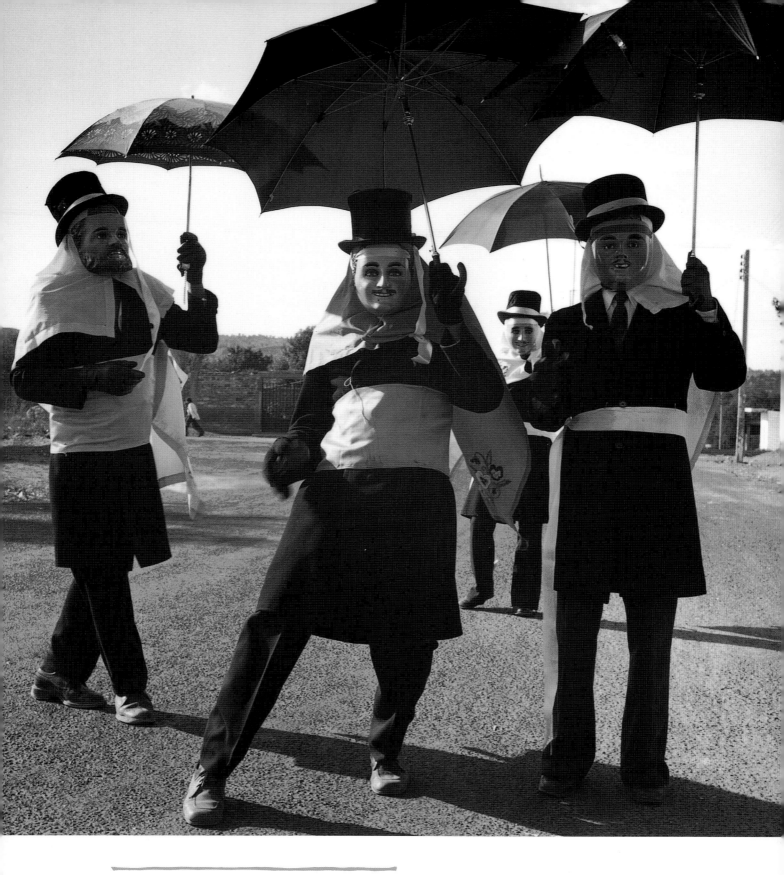

Catrines posing with open umbrellas as a petition for rain during the
Carnival festivities. Amaxac de Guerrero, Tlaxcala (Nahua), 1977.

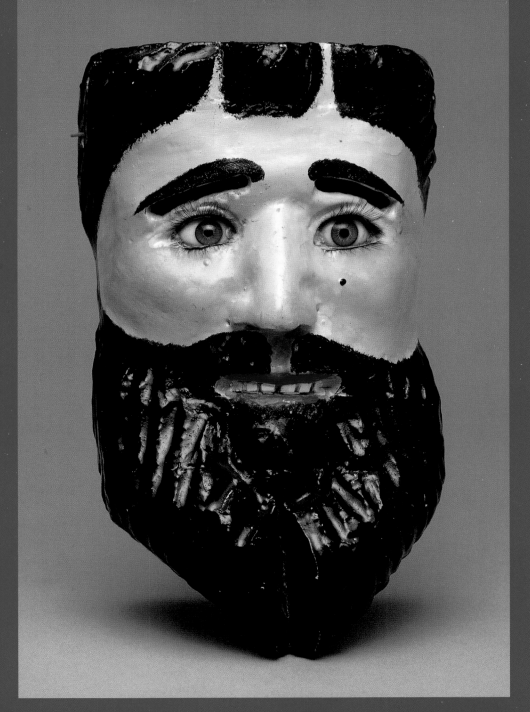

One well-known *santero* producing Carnival masks in Tlaxcala was Carlos Reyes Acoltzi, who lived in the Nahua community of Tlatempan until his death in 1982. This example would probably have been worn by a *Catrin* (Dandy) masquerader in villages north of the city of Tlaxcala. The use of glass eyes and false eyelashes adds to the realistic appearance of the face.

CATRIN MASK FOR CARNIVAL DANCES

Made by Carlos Reyes Acoltzi (?)

Tlatempan, Tlaxcala (Nahua)

c. 1953

H: 27.7 cm

IFAF – Purchased from José Reyes Juarez

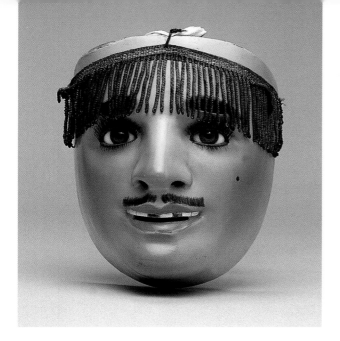

Some of the Carnival masks worn in the southern part of Tlaxcala are made in the nearby city of Puebla by the *santero* Enrique Méndez Hernández and his brother, Francisco. Their masks are beautifully crafted to give an ultra-realistic appearance. The style of mask shown here is often worn by *Charro* masqueraders in the sothern part of the state.

◀ ***CHARRO*** OR ***PARAGÜERO*** MASK FOR CARNIVAL DANCES

Made by Méndez Hernández family

Puebla, Puebla

1987

H: 19 cm

IFAF – Purchased from Méndez Hernández family

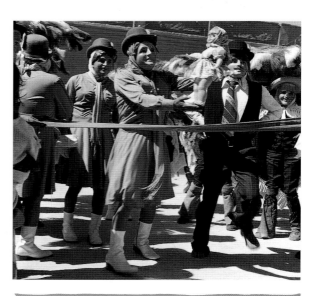

During the Carnival performance of the *Charros,* a man masquerading as a woman presents a doll to the audience as a symbol of fertility. San Cosme Mazotecochco, Tlaxcala (Nahua), 1978.

▲ This female mask is worn by a young man who accompanies the *Charros* and acts out the character of a girl who falls in love with a handsome cowboy. The baby doll she presents to the crowd is a symbol of that relationship.

MUJER MASK FOR CARNIVAL DANCES

Worn in southern Tlaxcala (Mestizo)

Made by Enrique Méndez Hernández, from Puebla, Puebla.

1987

H: 22.5 cm

IFAF – Purchased from Enrique Méndez Hernández

Morelos

Morelos is populated by Nahua people whose masked dances have been gradually dying out. However, in the town of Tepoztlán and the surrounding villages some masked festivals are still carried out. The most important of these is Carnival, which features *Chinelos,* whose name refers to a man who moves his hips and shoulders. *Chinelos* wear wire-screen masks with large, elaborately decorated hats and long velvet gowns. Despite the heavy costume, they leap

CENTRAL
REGION

around the plaza for hours at a time while hundreds of people watch the spectacle. Although the origins for this performance are unclear, it probably relates to similar leaping displays by Carnival masqueraders in the Galicia region of northwestern Spain still performed today. In Europe the leaping is associated with spring planting, with the height of the jumps symbolizing the tallness of the crops for the coming season.

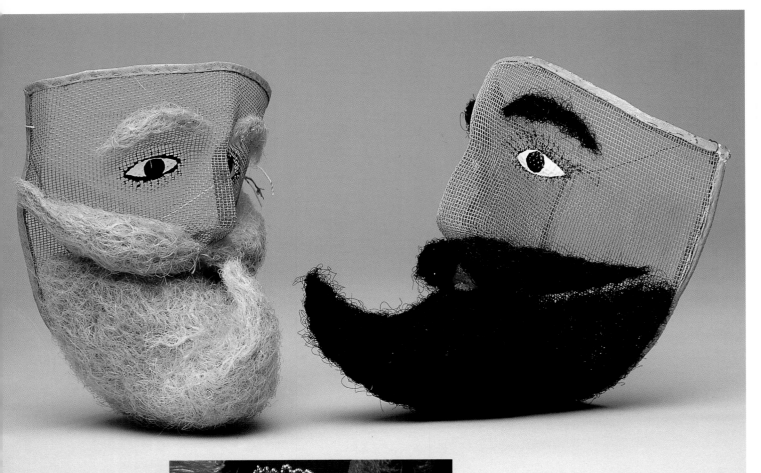

The *Chinelos* wear lightweight masks made from wire screen and decorated with horsehair eyebrows, mustache, and beard. This comfortable and effective style of mask was introduced from central Europe but its use in Mexico seems to be confined to the *Chinelos*, who appear in dances in Morelos and, to a lesser extent, in the states of Mexico, Tlaxcala, Puebla, and Veracruz.

CHINELO MASKS FOR CARNIVAL DANCES

Tepoztlán, Morelos (Nahua)

c. 1965

H: 19.3 cm

MNM – Gift of Kathleen and Robert Kaupp

Michoacán

Michoacán is the home of the Tarascan Indians, also known as the *Purepecha*, who live in a number of towns and villages spread throughout the northern part of the state. These native people have a strong festival tradition with a wide range of mask types. Some of the best-known dances feature *Viejos* who perform for various religious feast days. In the region around Lake Pátzcuaro their masks portray comical old men and women with gaps between their teeth who do a lively dance with synchronized stomping of their feet.

In the mountain villages north and east of Uruapan, the *Viejo* characters and masks are generally more dignified, perhaps because they primarily perform during the Christmas season to honor the Christ Child and the *mayordomos* (caretakers of the religious images) who change office at the beginning of the new year. Alongside the highland *Viejo* groups are the *Negritos*, who are considered to be the most prestigious dancers to perform for the Christ Child. They wear elegant clothing with long colorful ribbons. Their black masks generally have very fine features, with subtle differences in style from one village to another. In some highland towns, such as Charapan, another type of character appears known as the *Corcoví*, whose mask is stylized with fair skin, large eyes, long nose, and deep incising in the mustache and beard.

The town of Uruapan is particularly known for its mask makers, who produce well-carved pieces finished with a glossy lacquer technique. The Magdalena *barrio* in this city has a lively celebration for its patron saint's feast day, when a variety of masked characters parade through the town. Some of the most striking are the *Negritos*, who often wear large sheepskins over their head and shoulders. Other characters, known as *Hortelanos*, perform an agricultural dance wearing much cruder masks made from gourds and costumes adorned with plant foods.

The *Pastorelas*, or nativity plays, are popular in many *Purepecha* communities, and although the masks range in style from town to town they usually portray youthful (sometimes comical) shepherds, dignified old male hermits, and fanciful devils with large teeth and horns. *Pastorela* dramas are also performed in mestizo towns in the very northern part of the state, where the masks are similar to those found over the border in Guanajuato.

The Moor and Christian pageant is another popular event in some highland villages of Michoacán, particularly for feast days of the patron saints. Although older masks do appear in collections, many of these dramas are carried out with elaborate headdresses and kerchiefs over the faces rather than masks. Carnival is celebrated in a few areas, such as Charo and neighboring towns to the east of Morelia, where the masquerades include a *Viejo* in a comical bullfight. Carnival has also been popular in the village of Cuanajo, southeast of Pátzcuaro, where the variety of masks includes a distinctive style of dog.

Other mask dances are unique to specific areas. One of these is *El Pescado*, performed in the Lake Pátzcuaro region, wherein a large fish structure is carried on the head of the dancer. He is pursued by fishermen wearing beautiful masks with golden beards. Another example is the Dance of the *Tigres* carried out in the *Purepecha* town of Coeneo, north of Lake Pátzcuaro. Here hundreds of dancers wear *Tigre* masks made of dried deerskin taken from the face. Deer antlers are decorated with ribbons and fruit.

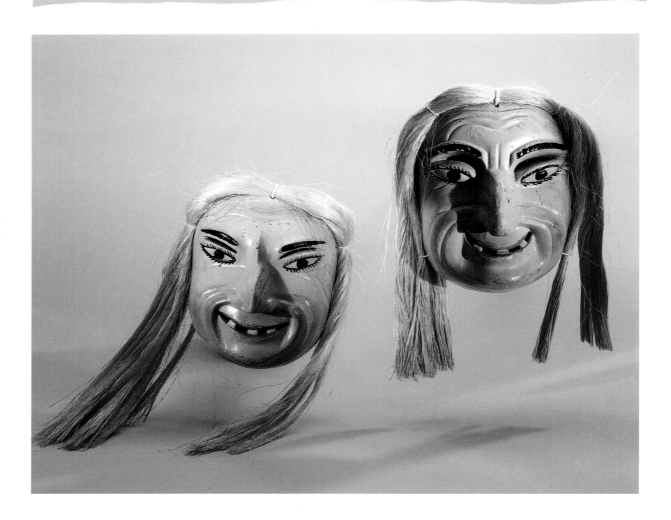

The *Viejitos* dances in the Lake Pátzcuaro region of Michoacán are distinguished by troupes of performers wearing masks portraying old men with wide grins and spaces between their teeth. The *Viejitos* generally perform stooped over a wooden cane, and at a certain point the dance becomes quite vigorous with repeated stomping of the feet. These are good examples of older *Viejo* masks from the 1930s, but the strands of hair, made from plant fiber, were a later addition.

VIEJO MASKS FOR LOS VIEJITOS DANCE

Made by Nicolas Juarez

Jarácuaro, Lake Pátzcuaro, Michoacán (Tarascan)

c. 1935

H: 17 cm (masks only)

IFAF – Purchased from Nicolas Juarez

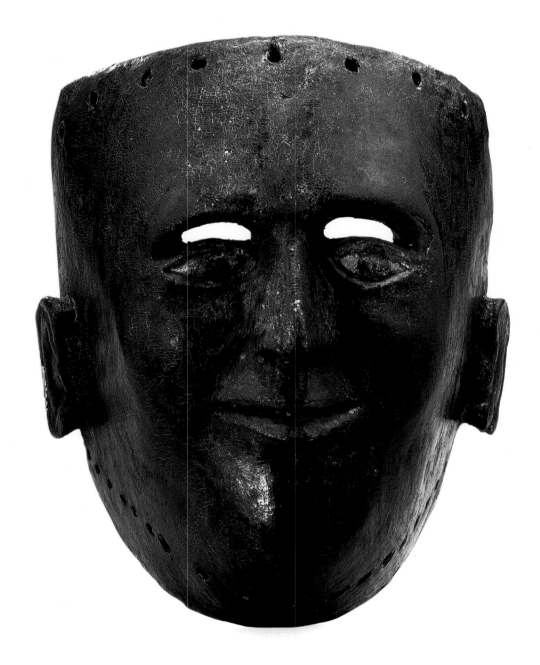

In the highland region, *Negrito* dancers play a major role in the Christmas season festivities that honor the Christ Child. This is a beautiful example of an older *Negrito* mask from one of the Tarascan mountain villages, possibly Cherán. The holes across the forehead were used to attach an elaborate crown, and those under the chin secured a decorative collar or fringe.

NEGRITO MASK FOR WINTER DANCES

Possibly Cherán, Michoacán (Tarascan)

c. 1940

H: 21 cm

MNM – Gift of the Girard Foundation

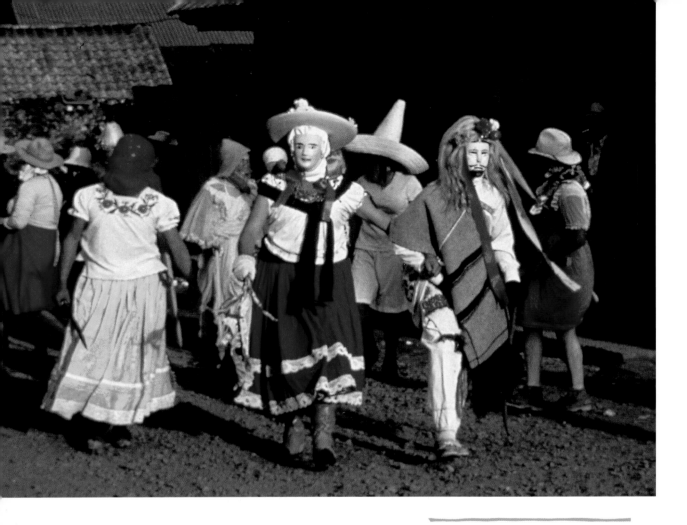

Viejo and *Maringuilla* masqueraders walking arm in arm during the New Year's Day festivities. San Lorenzo, Michoacán (Tarascan), 1987. Photograph by Marsha Bol.

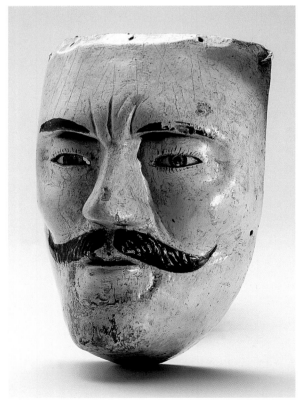

The artists of Uruapan have been known for their fine lacquerware trays, which technique is also used to finish the surface of carved religious images for churches and private chapels. In the past, some *santeros* from this town also made masks. This beautiful example from the late nineteenth century shows the fine quality of skin texture achieved through the lacquer process. The glass eyes add to the realistic quality of this *Viejo's* face, who played a dignified grandfather figure.

VIEJO MASK FOR WINTER DANCES

Uruapan region, Michoacán (Tarascan)

Nineteenth century

H: 20.5 cm

IFAF – Purchased from Enrique Luft

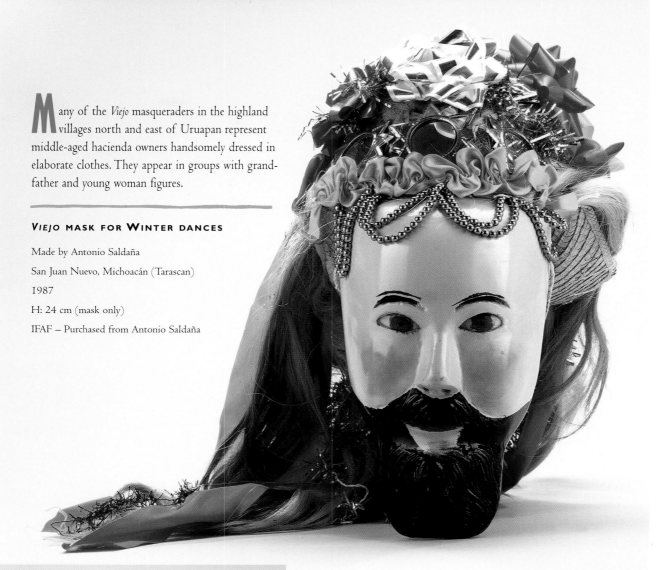

Many of the *Viejo* masqueraders in the highland villages north and east of Uruapan represent middle-aged hacienda owners handsomely dressed in elaborate clothes. They appear in groups with grandfather and young woman figures.

VIEJO MASK FOR WINTER DANCES

Made by Antonio Saldaña

San Juan Nuevo, Michoacán (Tarascan)

1987

H: 24 cm (mask only)

IFAF – Purchased from Antonio Saldaña

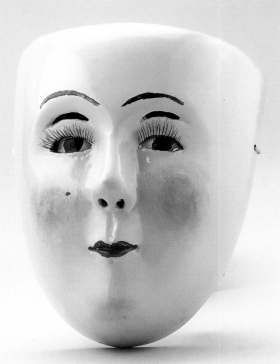

In this example the mask maker has captured the expression of a sweet girl with long eyelashes, rosy cheeks, and tight red lips. The mask and costume, however, are worn by a man acting out the character of the young woman, known as *Maringuilla* (Little Mary). She is often seen dancing arm in arm with the grandfather *Viejo* figure.

MARINGUILLA MASK FOR WINTER DANCES

Made by Antonio Saldaña

San Juan Nuevo, Michoacán (Tarascan)

1987

H: 19 cm

IFAF – Purchased from Antonio Saldaña

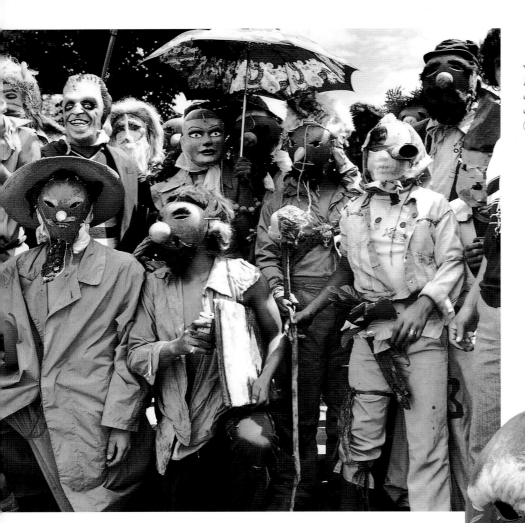

Hortelanos interacting with the crowd during the feast day procession. Barrio de Magdalena, Uruapan, Michoacán (Tarascan), 1980.

Each year on July 22, an agricultural dance is performed for the patron saint feast day of the *barrio* Magdalena, in Uruapan. The *Hortelanos*, or farm workers, are played by young and old alike. Their masks are made from a variety of plant materials such as *plantón* leaves or gourds, as seen here. Their costumes are adorned with plant foods such as ears of corn, onions, and herbs, thus showing the wearers' connection to the crops and hopes for a good harvest.

HORTELANO MASK FOR DANCE OF THE HORTELANOS

Made by Marcelino Báez(?)

Uruapan, Michoacán (Tarascan)

1987

H: 30 cm

IFAF – Purchased from Victoriano Salgado

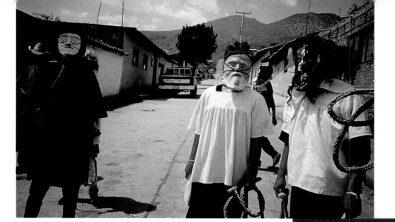

Shepherd, hermit and devil masqueraders in the *Pastorela* drama. Janamuató, Michoacán (Mestizo), 1988. Photograph by Estela Ogazón.

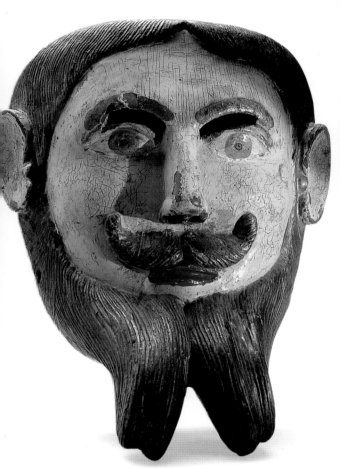

This is another example of an older, beautifully executed mask. The character of the Hermit in Michoacán *Pastorela* dramas is often portrayed as a dignified older man with mustache and full beard. Here the artist carefully carved fine detailing of the hair. The original painting of the skin surface was probably done in the lacquer technique.

HERMIT MASK FOR *PASTORELA* DRAMA

Michoacán (Tarascan)

Early twentieth century

H: 25 cm

MNM – Gift of the Girard Foundation

In contrast to the *Pastorela* Devil masks from Guanajuato, those worn in Michoacán tend to feature horns and large teeth, creating a threatening expression as seen in these two examples. Although not as common, some devil masks in Michoacán also feature reptiles and insects on the face.

DEVIL MASKS FOR *PASTORELA* DRAMA

(left) Michoacán (Tarascan)

c. 1930

H: 28 cm

(right) Charapan (?), Michoacán (Tarascan)

c. 1940

H: 32 cm.

MNM – Gift of the Girard Foundation

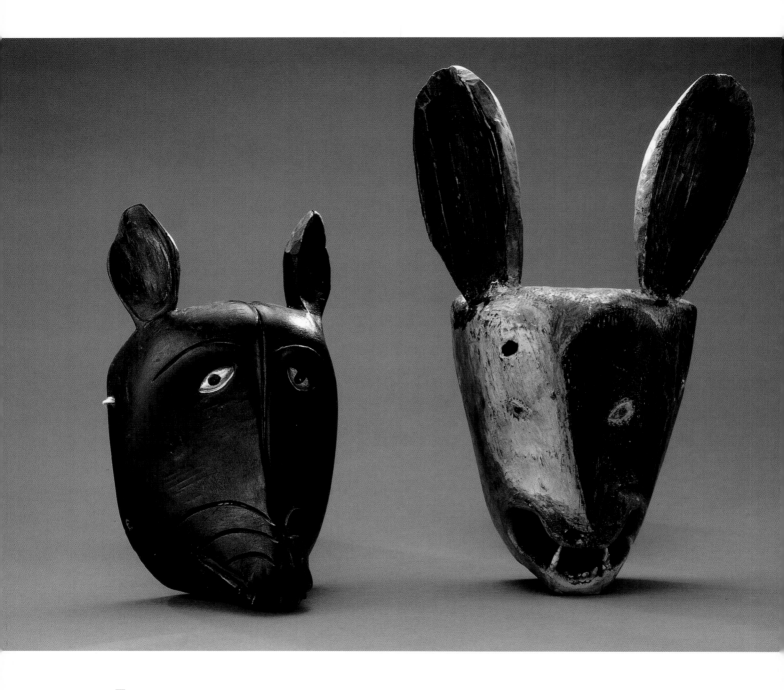

At one time a variety of dog masqueraders appeared in the Carnival and feast day dances of Cuanajo, near the town of Pátzcuaro. Most of these masks have relatively small faces with carving that tends to feature the ears and long bridge of the nose, as seen in these examples. In the mask on the left, the face and ears were carved from one piece of wood.

DOG MASKS FOR CARNIVAL AND FEAST DAY DANCES

Cuanajo, Michoacán (Tarascan)
c. 1965
(left) H: 33.5 cm; (right) H: 27 cm
IFAF – Purchased from Enrique Luft

Guanajuato

Guanajuato *was a rich* mining center in the colonial era. Otomí Indians who inhabited the region were moved to Spanish settlements to work as laborers in the mines and wealthy plantations. Today most of the communities in the state are mestizo, reflecting the long Spanish and *criollo* presence in the area, and masked dramas tend to derive more from European traditions than Indian. A good example is the Christmas season *Pastorela* pageants, performed in *barrios* in large cities such as León and Salamanca, as well as in smaller ranching communities in the southwestern region of the state. The masquerades used to portray the hermit and the shepherds and Lucifer and other devils in this drama are quite elaborate and may display an underlying indigenous sensibility.

Holy Week is also a time for masked dramas, as seen in the town of San Bartolo Agua Caliente, located on the southwestern border with Querétaro. Here whole groups of *fariseo* masqueraders come out on Thursday and perform a mock battle before joining the religious procession. Many of

the devil-style masks worn here have a resemblance to those found over the border in the town of El Pueblito. The town of Purísima de Bustos, located near the eastern border with Jalisco, also has an elaborate Holy Week pageant that takes place over several days and involves many different masked characters.

Another legacy from colonial times is masked dramas portraying hacienda life during the wealthy mining era. An example is the Dance of the Little Bull, performed in the area around Silao, in the center of the state, and in ranching villages further south. Among the various masked characters are comical figures portraying drunken women.

Guanajuato's large industrial city of Celaya is also a center for the production of papier-mâché masks, with thousands being made and sold throughout Mexico each year. These inexpensive masks portray a variety of characters such as devils, *viejos*, skeletons, and animals, and are worn for Carnival and other festive celebrations.

The *Pastorela* hermit masks of Guanajuato often portray a grotesque character with mustache, beard, and long hair made from plant fibers.

HERMIT MASK FOR *PASTORELA* DRAMA

Guanajuato (Mestizo)

c. 1960

H: 25 cm

MNM – Gift of Girard Foundation

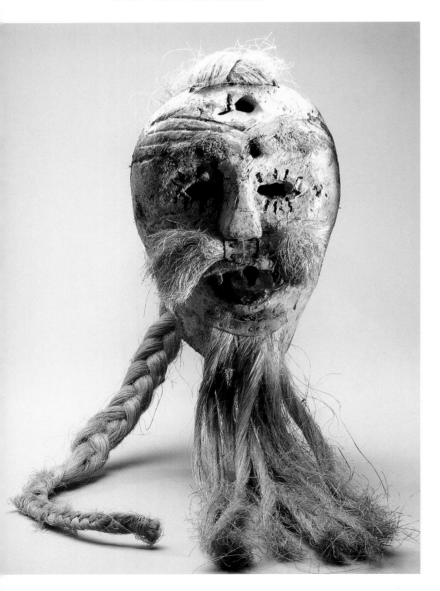

Unlike the other devils, Lucifer is generally portrayed with a human face since he was one of God's angels who fell from heaven. This is a particularly fine mask although it has been heavily overpainted from decades of use.

LUCIFER MASK FOR *PASTORELA* DRAMA

Guanajuato (Mestizo)

Early twentieth century

H: 47 cm

MNM – Gift of Girard Foundation

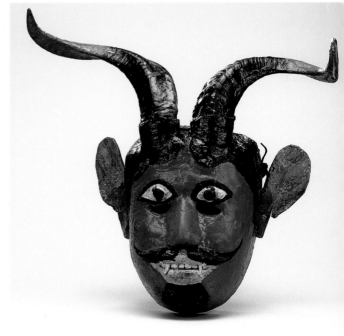

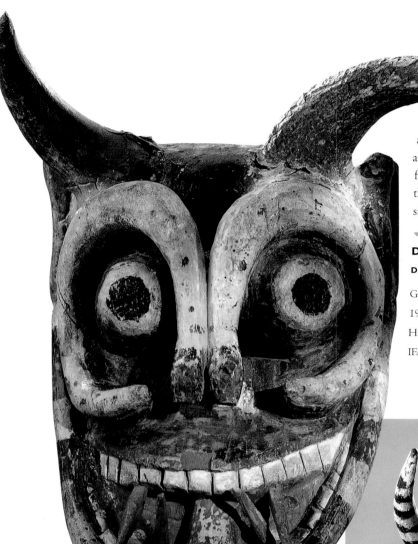

Many of the devil masks from Guanajuato are distinguished by a variety of snakes and other vermin or insects that cover the face. Here, two serpents are coiled around the large eyes and two more outline the sides of the jaws.

DEVIL MASK FOR THE *PASTORELA* DRAMA

Guanajuato (Mestizo)

1930s–1940s

H: 29.5 cm

IFAF – Purchased from the Cordry collection

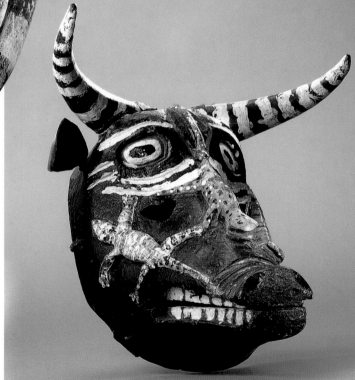

Although heavily overpainted, this is an early example of a Guanajuato Devil mask with reptiles carved on the face. This mask was constructed with a movable jaw, adding to its frightening effect.

DEVIL MASK FOR THE *PASTORELA* DRAMA

Guanajuato (Mestizo)

Early twentieth century

H: 31 cm

IFAF – Purchased from the Cordry collection

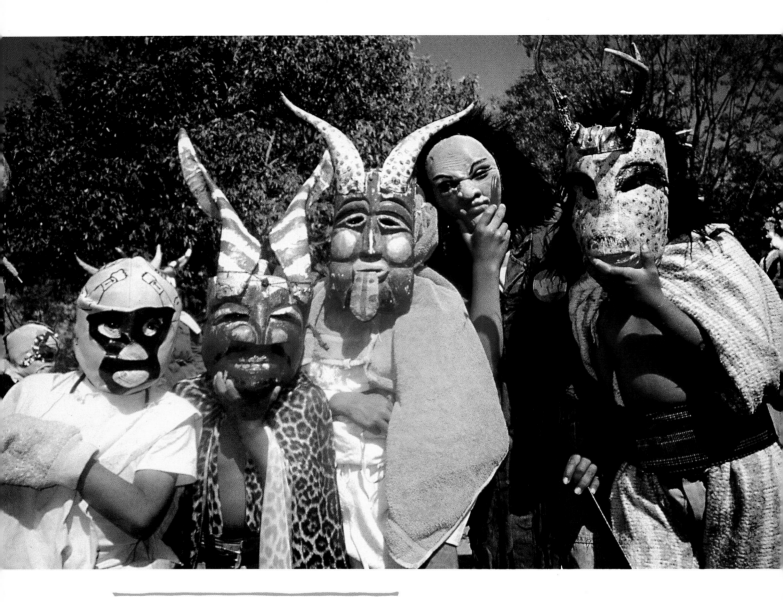

Fariseos mocking the Holy Week procession. San Bartolo Agua Caliente, Guanajuato (Mestizo), 1992. Photograph by Estela Ogazón.

Querétaro

Querétaro is inhabited by Otomí people living in farming villages in the southern part of the state and in a mountainous region in the northeastern section, bordering onto San Luis Potosí. One of the most notable masked performances in the state is found in the mountain region in the small highland community of El Doctor. During Holy Week, a large group of villagers plays the role of *fariseos* or *judíos* wearing a distinctive style of glued-fabric mask that portrays humorous men and women, as well as

WEST-CENTRAL REGION

devils, death, and a range of animals. In this guise, they follow and make fun of the serious Holy Week processions carried out by the Catholic priests and local brotherhood.

Carnival is also a time for celebration, particularly in some mestizo communities around the large capital city, Querétaro, in the western part of the state. El Pueblito is particularly known for its lively *diablo* masqueraders, who wear boldly painted masks with very large antlers and take joy in interacting with the crowds.

Judíos waiting for the Holy Week procession.
El Doctor, Querétaro (Otomí), 1977.

The Holy Week *Fariseo* or *Judío* masks from El Doctor are traditionally made from layers of fabric glued together over a mold. The surface is then painted in the likeness of the character being portrayed, such as the wolflike animal shown here. Long hair generally is attached to the top of the mask and worn down the wearer's back. In this example, the maker created the hair from a cotton-string mop.

FARISEO MASK FOR HOLY WEEK DANCES

El Doctor, Querétaro (Otomí)

c. 1955

H: 27 cm (mask only)

MNM – Purchased from Jaled Muyaes and Estela Ogazón

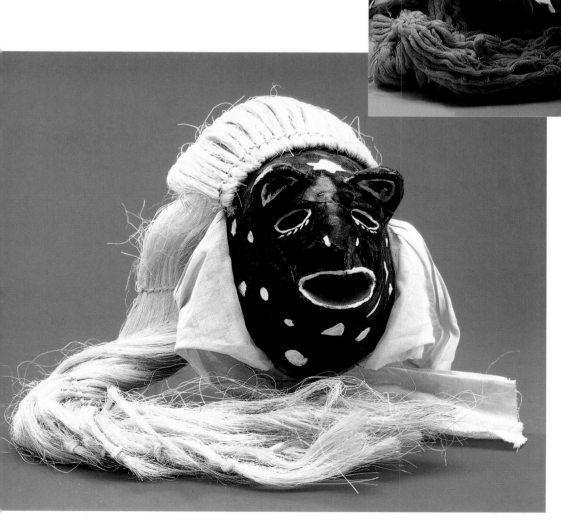

This recent example of a Holy Week *Fariseo* mask from El Doctor is made in the same technique of glued fabric as that shown above. Here, however, the maker has used ixtle fiber to create the hair, which is a more common material. The scarf attached around the sides of the mask help conceal the wearer's face.

FARISEO MASK FOR HOLY WEEK DANCES

El Doctor, Querétaro (Otomí)

Made by Guadalupe Olvera

1983

H: 22 cm

IFAF – Purchased from the Museo Nacional de Artes y Tradiciones Populares, Mexico City

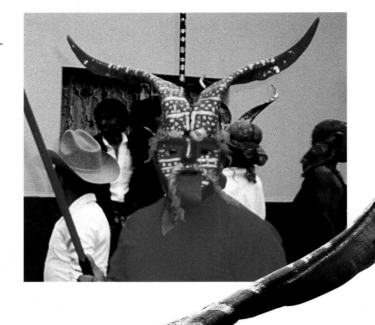

Diablo masquerader enjoying the Carnival festivities. El Pueblito, Querétaro (Mestizo), c. 1980. Photograph by Estela Ogazón.

Many of the devil masks worn for Carnival and the patron feast day in El Pueblito are characterized by large animal horns attached to the top of the head. The whole mask is then painted in bold geometric patterns of white or silver paint against a red background, creating a very striking presentation.

DEVIL MASK FOR CARNIVAL AND FEAST DAY DANCES

El Pueblito, Querétaro (Mestizo)
c. 1973
H: 56 cm (with horns)
IFAF – Purchased from Jaled Muyaes and Estela Ogazón

Jalisco

The territory that now encompasses the state of Jalisco in western Mexico was once inhabited by a number of different ethnic groups ruled by the Chimalhuacán Indians. The tyrannical Spaniard, Nuño Beltrán Guzmán, took over the area in 1530, crushing the indigenous kingdom and taking large populations of people into slavery. European colonists eventually established the city of Guadalajara, and many mestizo settlements grew up around it and in other parts of the fertile farming region.

The best-known masked dances in Jalisco today are the *Tastoanes*, performed in mestizo communities near Guadalajara and fanning out to the southwest toward Lake Chapala. This festival drama, often performed on July 25 in celebration of the feast day for Santiago, provides an interesting version of the Moor and Christian dance. In place of the Moors, the pagan infidels are the *Tastoanes*, whose name derives from a Nahua word meaning the "one who speaks," indicating the leader of an Indian group. As a twist to the usual story, the *Tastoanes* are victorious and capture and kill Santiago. Their masks generally have very grotesque features and long straggly hair, but the styles vary from place to place. These range from the brightly painted ceramic pieces from Santa Cruz de las Huertas to those made from wood and leather with words and images painted on the face, such as are worn in Tatesposco and Ocotlán.

Pastorela dramas are also performed in some of the mestizo towns around Guadalajara and Lake Chapala, as well as in other parts of the state, with participants wearing masks portraying humorous shepherds, hermits, and devils. Many of the *Pastorela* devil masks in Jalisco have animal features such as those worn in the city of Chapala that portray the face of a cow with deer antlers. The leather *Pastorela* devil masks of Cajititlán represent frightening creatures with long tongues and hugh masses of hair.

Another type of masked performance found in Jalisco is the *Danza de los Locos* (Dance of the Fools) that features a distinctive style of "fool" mask with a twisted, diagonal mouth. This dance is performed in the mestizo town Jocotepec, located on the west end of Lake Chapala, for the town's patron saint's feast day on January 20.

Nahua peoples living in the southern part of the state around the city of Tuxpan also perform masked dances. One of these is an agricultural drama known as *Paixtles*, where the performers' bodies are covered by a crude cape made of hay. Their wood or leather masks portray a combination of human and animal features.

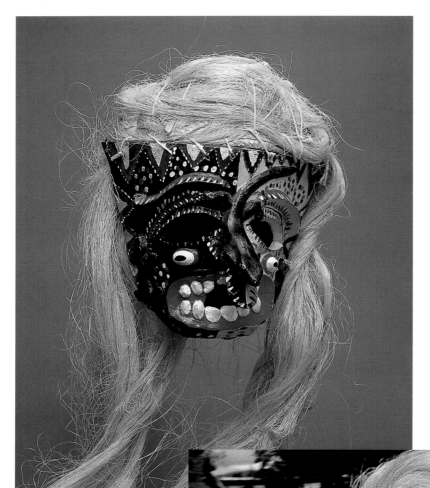

Tastoan masks from the ceramic-producing town of Santa Cruz de los Huertas are made of fired clay over a leather base. Sculpted with exaggerated features such as the nose and mouth, many also have reptiles applied to parts of the face, adding to the grotesque effect. They are then painted in bright colors and the hair, usually made from *ixtle* plant fibers, is attached with string to tiny holes across the forehead.

TASTOAN MASK FOR TASTOANES DANCE

Probably made by Candelario Medrano
Santa Cruz de las Huertas, Jalisco
1983
H: 20.3 cm (mask only)
IFAF – Purchased from Victor Fosado

Tastoan wearing a painted leather and wood mask for the *Tastoanes* dance drama. San Juan Ocotlán, Jalisco (Mestizo), c. 1980. Photograph by Estela Ogazón.

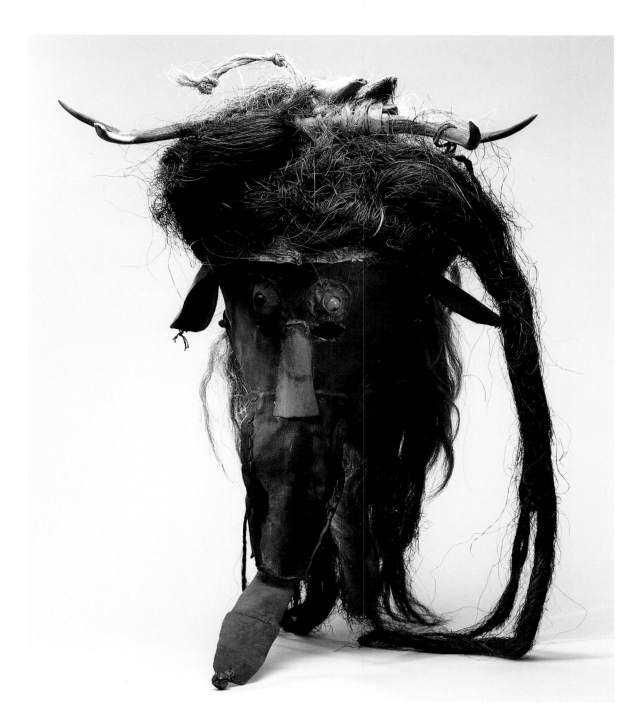

This striking *Pastorela* devil mask from Cajititlán is made from sewn leather with long hair and antlers attached to a straw hat. The eyes are inset with marbles. Some of the other leather devil masks from this community have reptiles painted on the face, adding to the frightening effect. This style of mask would also be appropriate to portray a *Tastoan*.

DEVIL MASK FOR *PASTORELA* DRAMA

Made by David Ricos

Cajititlán, Jalisco

c. 1950

H: 76 cm (with horns)

IFAF – Purchased in Cajititlán

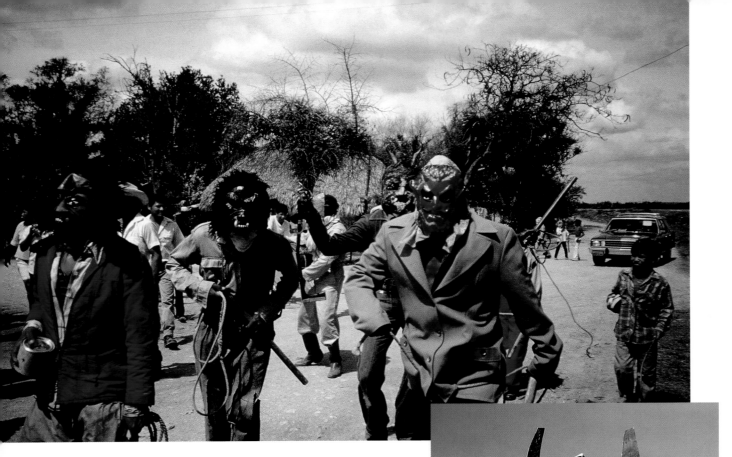

Diablos in the *Pastorela* drama. Larga de Morena, Jalisco (Mestizo), 1989. Photograph by Estela Ogazón.

Since the 1970s some mask makers in Cajititlán have utilized recycled cans and scrap metal to construct *Pastorela* devil masks, as seen here. The overall effect, however, is not as frightening as with the leather masks.

DEVIL MASK FOR *PASTORELA* DRAMA

Cajititlán, Jalisco

c. 1995

H: 38 cm

IFAF – Purchased from Sergio Roman Rodriguez

Colima

The area that now comprises the small state of Colima was, along with neighboring Jalisco, taken over by Spaniards early in the colonial era. Most of the Indian people became laborers for the Europeans, and today there are a number of mestizo towns and villages spread throughout the state.

During the Christmas season, *Pastorela* dramas are carried out in many of these communities, with performers wearing very elaborate and well-made masks. In some towns

such as Lo de Villa, near the capital city of Colima, a Death character appears among the masqueraders.

One of the few Nahua villages is Suchitlán, located in the northern part of the state. Here the townspeople perform the *Pastorela* drama as well as other masked dances at different times of the year. One of these, known both as the Dance of the *Morenos* and Dance of the *Animals*, features pairs of animals with expressive faces.

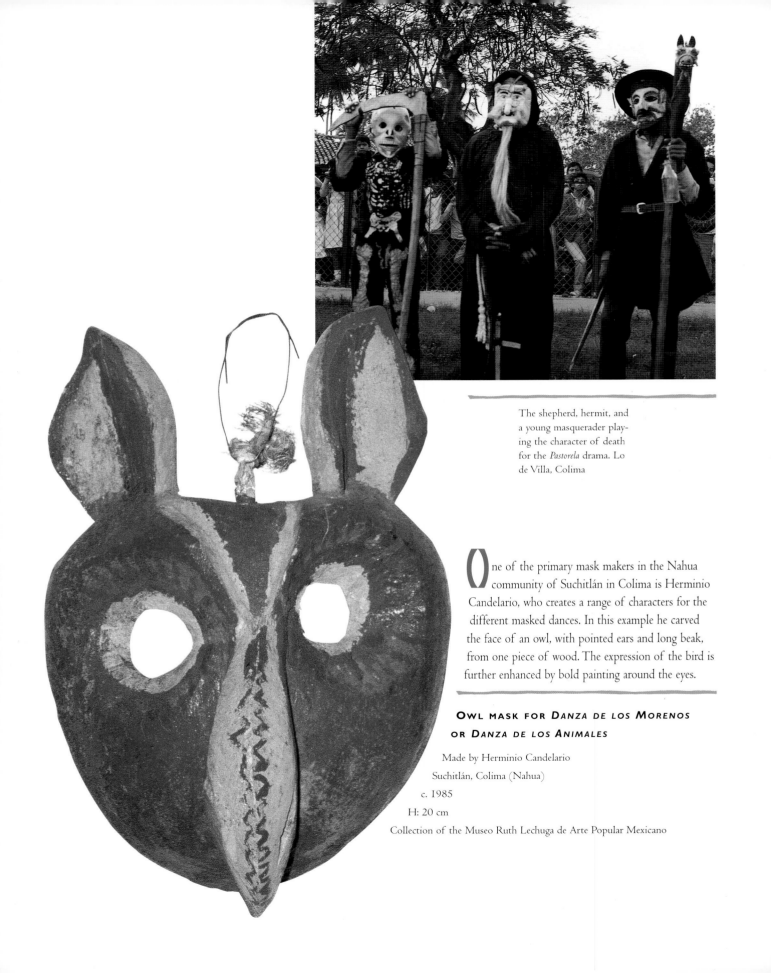

The shepherd, hermit, and a young masquerader playing the character of death for the *Pastorela* drama. Lo de Villa, Colima

One of the primary mask makers in the Nahua community of Suchitlán in Colima is Herminio Candelario, who creates a range of characters for the different masked dances. In this example he carved the face of an owl, with pointed ears and long beak, from one piece of wood. The expression of the bird is further enhanced by bold painting around the eyes.

OWL MASK FOR *DANZA DE LOS MORENOS* OR *DANZA DE LOS ANIMALES*

Made by Herminio Candelario

Suchitlán, Colima (Nahua)

c. 1985

H: 20 cm

Collection of the Museo Ruth Lechuga de Arte Popular Mexicano

Zacatecas

Zacatecas was a particularly rich mining region that drew large numbers of Spanish and *criollos* into the territory. Most of the nomadic Indian groups who inhabited the area were either taken as slaves to work in the mines or driven out to other regions. Today Zacatecas is primarily made up of a mestizo population living in cities, towns, and ranches spread throughout the southern half of the state. Most of the festival dances derive from the Moor and Christian drama, such as the large pageant, called *Los Morismas*, performed in the city of Zacatecas in late August. A great battle scene is reenacted on the top of a nearby hill, with costumed actors on foot and horseback, but it is not customary for them to wear masks.

Another version of the Moor and Christian drama, known as *Los Matachinas*, is performed around the city of Zacatecas as well as in other areas of the state. *Matachinas* is the Spanish term for clowns, and the whole pageant takes on a humorous tone. The *Tastoanes* variant to this drama is very popular in the southern end of the state, in such towns as Tlatenango, Juchipila, and Moyahua. The *Tastoanes*, or Mexican Indian leaders who kill Santiago, wear a variety of grotesque masks, many of which have black faces.

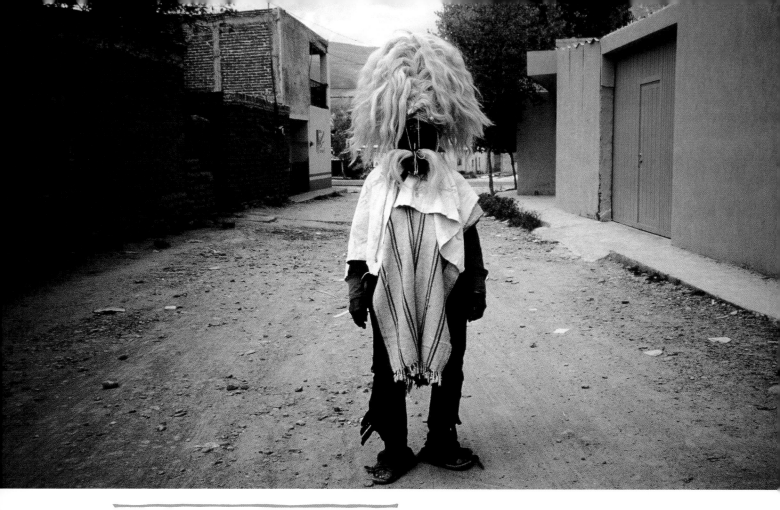

Tastoan wearing a large wig and grotesque mask, in keeping with his role in the Tastoanes drama. Moyahua, Zacatecas (Mestizo), c. 1985. Photograph by Estela Ogazón.

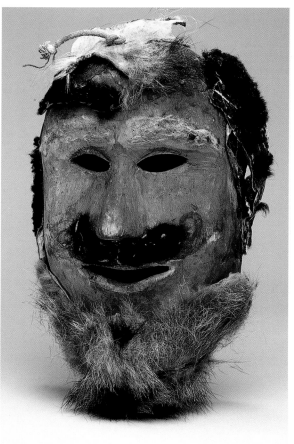

Dance masks from Zacatecas tend to be simply carved, with animal hides attached for hair. Despite the primitive nature of this example, the expression is quite dynamic and comical in keeping with the humorous nature of this dance. It is from a town in the southeastern part of the state. Around the city of Zacatecas, however, the Matachina performers tend to wear scarves over their faces rather than masks.

MATACHINA MASK FOR DANCE OF THE MATACHINAS

Villa Garcia, Zacatecas (Mestizo)

c. 1965

H: 33 cm

IFAF – Purchased from the Cordry collection

Nayarit

Nayarit is the home of the Cora and Huichol peoples who took refuge in the isolated region of the Sierra Madre Occidental Mountains after the Spanish conquest. Although the Huichol have rich ceremonial and festival practices, masking is not part of their tradition. One exception is during their First Fruits ceremony, when a simple wooden mask is worn by a dancer who takes the role of a sacred clown. Since the 1960s this style of mask has been reproduced for sale to tourists, painted with brightly colored patterns or covered with fine beads.

The most important masked celebration for the Cora Indians takes place during Holy Week, when aspects of

Christian observances are syncretized with the traditional initiation rites of young men. In the town of Jesús María there are hundreds of male participants who appear in loincloths with patterns painted on their skin. They also make their own papier-mâché masks resembling animals and devils. Although they are referred to as *judíos*, the masks are said to represent the Cora's ancestors. Each day of Holy Week the colors used to paint the bodies and masks change, having symbolic meaning to the different events taking place. On Holy Saturday, when the rituals have been completed, the dancers destroy the masks in the river.

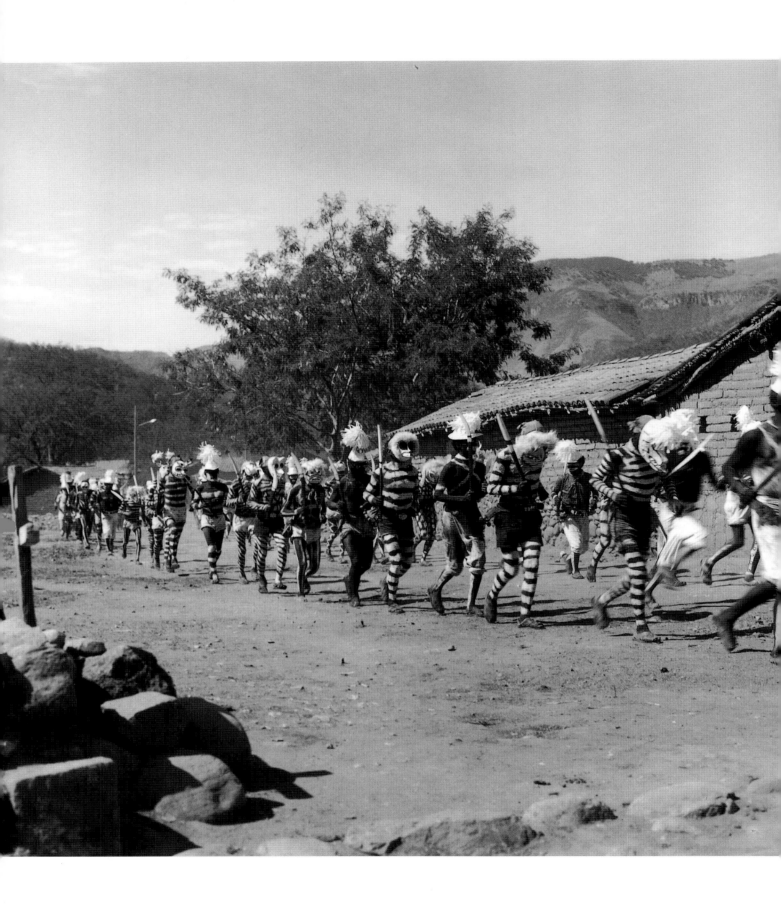

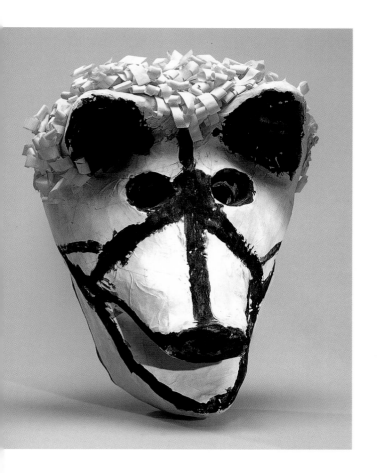

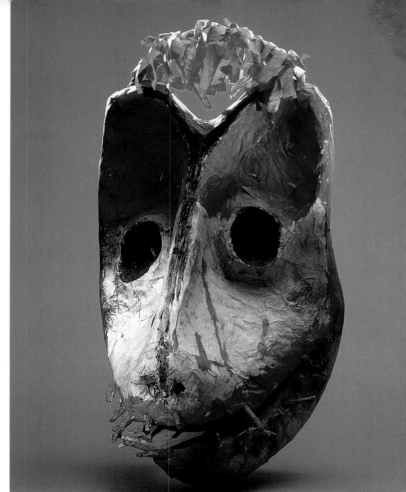

On Thursday of Holy Week, Cora men go to the bank of the river and paint their bodies and masks black and white. As soon as this is finished, the men take on entirely new personalities and begin saying things that are the opposite of what they want to express. In this guise, the performers represent the forces of night, which are the enemies of the sun, symbolized by Christ.

JUDÍO MASK FOR **HOLY WEEK PERFORMANCES**

Jesús María, Nayarit (Cora)

c. 1970

H: 25.5 cm

IFAF – Purchased from Elizabeth Cuellar

On Good Friday the painting on the Cora men's bodies and masks becomes multicolored, with a predominance of blood red, symbolizing the crucifixion of Christ. Their performance during this day conveys a mood of apprehension and remorse.

JUDÍO MASK FOR **HOLY WEEK PERFORMANCES**

Jesús María, Nayarit (Cora)

c. 1970

H: 48 cm

IFAF – Purchased from Elizabeth Cuellar

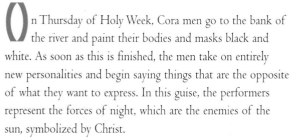

◄ A line of men with painted skin and wearing papier-mâché masks performs during the Holy Week initiation rites. Jesús María, Nayarit (Cora), c. 1975.

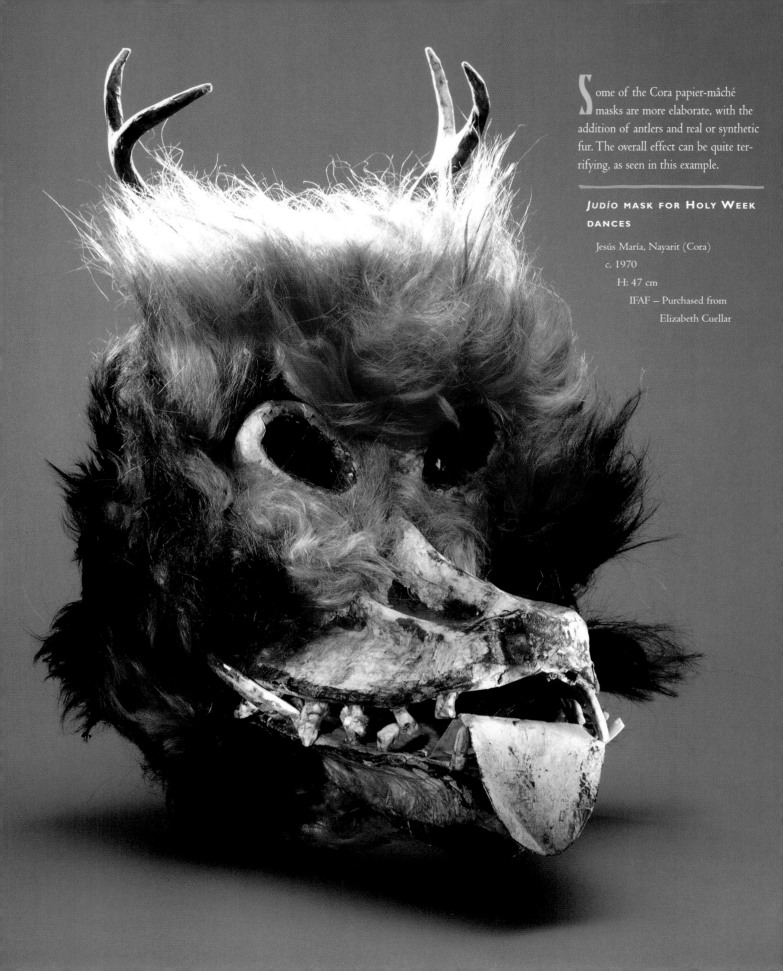

Some of the Cora papier-mâché masks are more elaborate, with the addition of antlers and real or synthetic fur. The overall effect can be quite terrifying, as seen in this example.

JUDÍO MASK FOR **HOLY WEEK** DANCES

Jesús María, Nayarit (Cora)

c. 1970

H: 47 cm

IFAF – Purchased from
Elizabeth Cuellar

Sinaloa and Sonora

Among the Indian groups in northwestern Mexico, the Yaqui and Mayo are particularly known for their masked performances. Although living in different areas of Sinaloa and Sonora, these two groups share certain characteristics in their dance dramas, reflecting regional Indian traditions overlaid with Catholic missionary practices.

Some of their most important masked performances take place in the weeks leading up to and including Holy Week. Groups of young Mayo and Yaqui men come together early in the Lenten season to travel around the countryside performing dances to collect alms for the Holy Week festivities. These masqueraders are variously referred to as *chapokobam*, *fariseo*, or *judíos*, representing Christ's persecutors. They wear a distinctive type of helmet mask, with specific styles varying from one town to the next. These are often made by the dancer himself and portray such things as animals, old men, and lewd women. The performances of the *chapokobam* increase in intensity during Holy Week when the dancers participate in the community religious processions, acting as clowns and making fun of the

liturgical activities. Finally, on Saturday evening they take off their masks and burn them as part of a ritual cleansing.

Other important forms of masquerade in this region are the *Pascola* and deer dances. These are performed for a variety of occasions, including Easter Sunday. The *Pascola* signifies an old man or ancestor of the community who is thought to communicate between the villagers and their deities through the medium of dance. He entertains the crowd by narrating the history of the group and telling stories with sexual themes. He wears a small wooden mask with the features of an old man or goat, with subtle style variations from one region to another.

The *Pascola* is usually accompanied by a deer dancer who wears an actual deer head fastened over his forehead. The two of them act out a hunting scene and end the performance with a dance. This has roots in pre-Hispanic ritual performance when the inhabitants of this region were dependent on hunting and used this type of dance to communicate with the animals about why they needed to kill them.

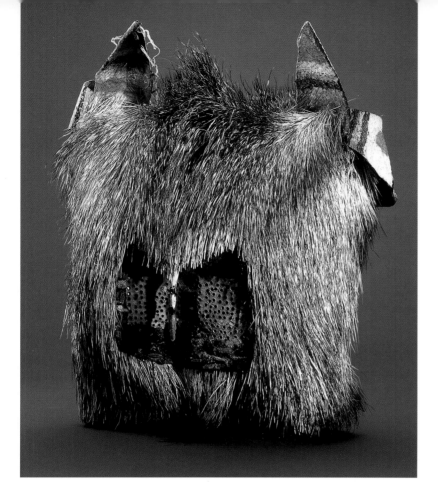

The *Chapokobam* performers generally wear helmet masks with distinctive styles to each village or region. Mayo masks from La Florida, Sinaloa, often portray stylized animals made from goat or *javelina* (wild pig) pelts, as seen in this example.

CHAPOKOBAM MASK FOR LENT AND HOLY WEEK ACTIVITIES

Made by Eraglio Zacarias
La Florida, Sinaloa (Mayo)
1974
H: 73 cm
IFAF – Gift of Barney Burns

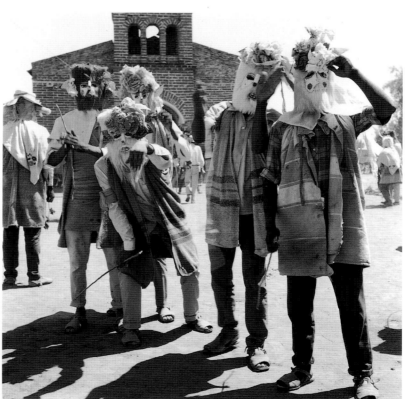

Chapokobam performing humorous acts during the Holy Week activities. Bacavachi, Sonora (Mayo), 1971.

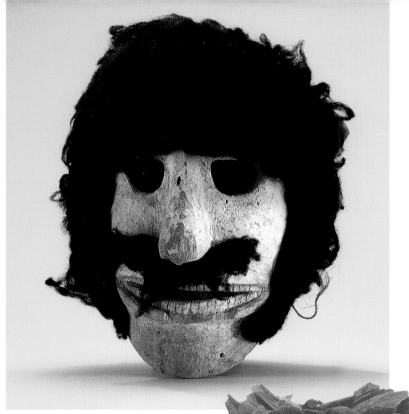

Another popular style of mask are those portraying old women and old men, as seen in this Mayo example from Rancho Igual.

CHAPOKOBAM MASK FOR LENT AND HOLY WEEK ACTIVITIES

Made by Juan Torres
Rancho Igual, Sinaloa (Mayo)
1980
H: 21 cm
IFAF – Purchased from Barney Burns

Masks showing lewd or sexy women are also popular among the young men, particularly in the larger mestizo town of Mochicahui.

CHAPOKOBAM MASK FOR LENT AND HOLY WEEK ACTIVITIES

Made by Ramón Enrique Ramos Cota
Mochicahui, Sinaloa (Mayo/Mestizo)
1988
H: 34 cm
IFAF – Purchased from Felipe Ramos Cota

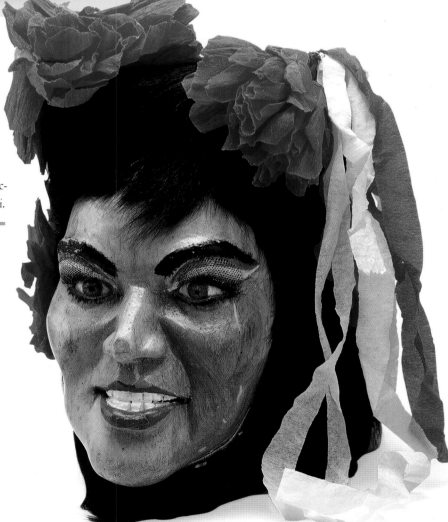

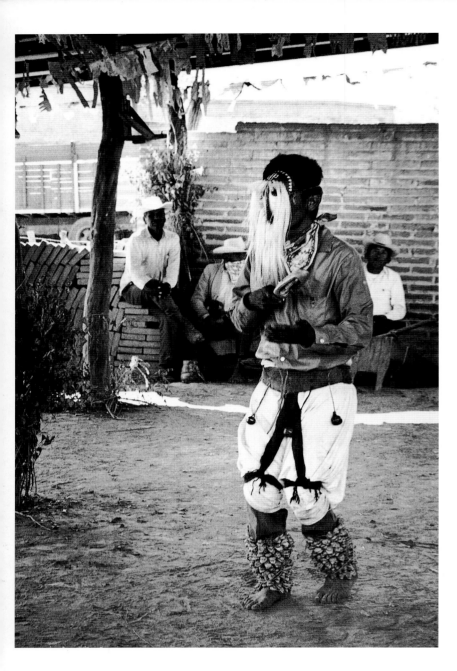

▶

Older *Pascola* masks had geometric patterns incised into the wooden face and some were even decorated with small mirrors. By the 1950s, however, most mask makers were simply painting these designs onto the wood, as seen here. A cross is always painted on the forehead, said to give the *Pascola* protection from Catholic priests. The eyebrows and beards on the mask are created by carefully inserting goat hair into tiny holes. The Yaki cut the eyebrow hair short, while the Mayo prefer to leave it long and flowing.

PASCOLA MASK FOR EASTER AND OTHER DANCES

Sonora (Yaqui)

c. 1960

H: 35 cm

MNM – Gift of the Girard Foundation

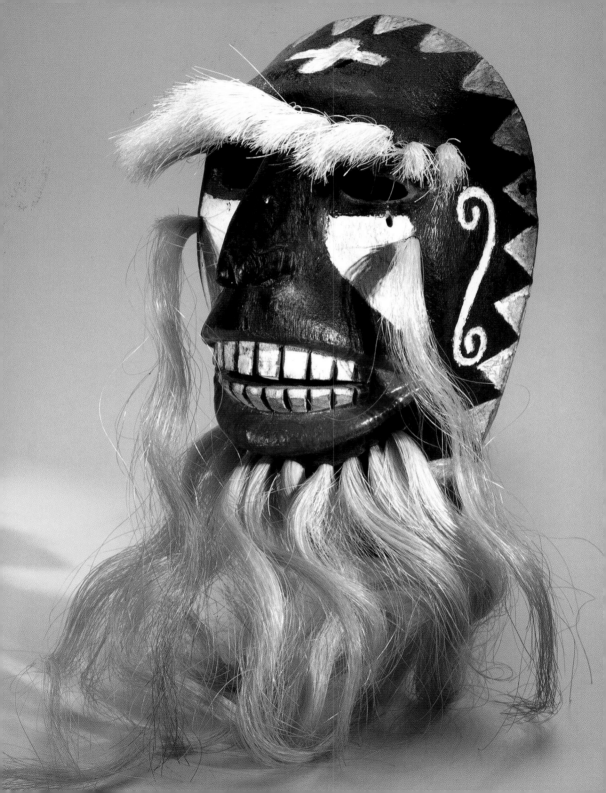

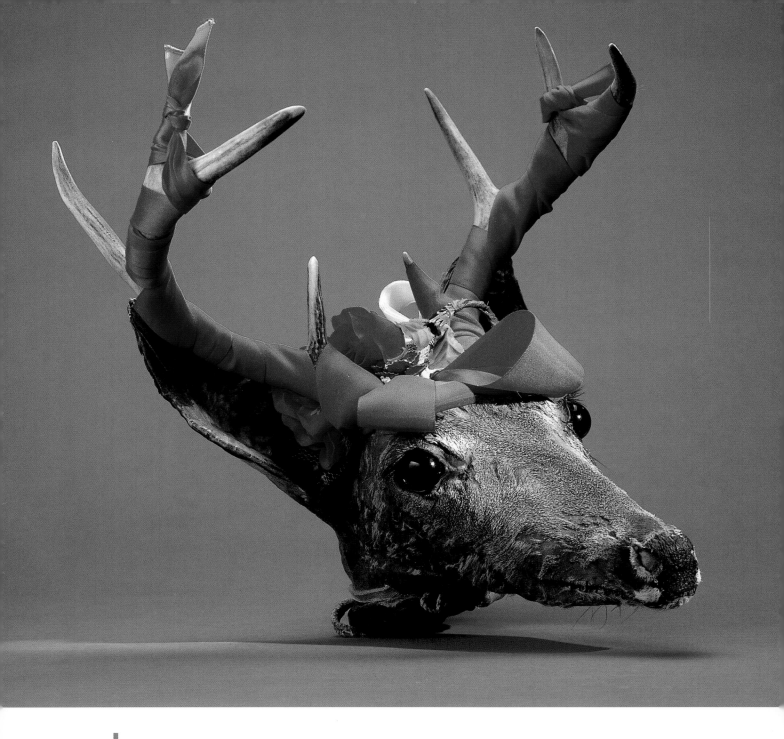

Instead of wearing a mask over the face, Yaqui and Mayo Deer dancers wear an actual deer head fastened to the forehead. This is probably closer to pre-Hispanic costuming traditions, where the dancer is thought to embody the spirit of the hunted animal.

DEER HEADDRESS FOR DEER DANCE

Sonora (Yaqui)

c. 1984

H: 32.7 cm

IFAF – Purchased from Jim Hills

Annotated Bibliography

Beals, Ralph L. *Cherán: A Sierra Tarascan Village*. Washington, D.C.: Smithsonian Institution, 1946.

An interesting ethnographic study of the Tarascan village of Cherán in the highland region of Michoacán that provides descriptions and discussion of their festivals and masked dances with a few black-and-white photographs.

_____. *Ethnology of the Western Mixe*. New York: Cooper Square Publishers, Inc., 1973.

A republished version of another ethnographic study conducted by Beals in the Mixe villages in the Sierra Juarez region of Oaxaca in which he describes the festivals, types of dances, and costumes and masks worn.

Benítez, Fernando. *Los Indios de México*. 5 vols. Mexico: ERA, 1970.

A highly respected study of the history and current life of several different ethnic groups of Mexico. Volume three is particularly important in providing a great deal of information on the religious ceremonies of the Cora peoples of Nayarit and includes many photographs of masqueraders performing during the Holy Week initiation rites.

Bricker, Victoria. *Ritual Humor in Highland Chiapas*. Austin: University of Texas Press, 1973.

Drawing from her extensive years of ethnographic fieldwork in the highland villages of Chiapas, Bricker provides rare insights into the sacred meaning of comic behavior carried out in ceremonial and festival contexts. Among these discussions are descriptions of the dance dramas and the costumes and masks worn by performers.

Brooks, Francis Joseph. *Parish and Cofradía in Eighteenth-Century Mexico*. Ph.D. dissertation, Princeton University, 1976.

One of the few in-depth studies of the *cofradía* system as it evolved in Mexico during the Spanish colonial era. Included is an excellent discussion of the pre-Hispanic *calpulli* and how it related to the subsequent *barrio* and *cofradía* organizational structures. It is available through UMI Dissertation Services, Ann Arbor, Michigan.

Brown, Betty Ann. *Máscaras. Dance Masks of Mexico and Guatemala*. Normal: University Museums, Illinois State University, 1978.

A catalogue to an exhibition with an interesting essay by Brown discussing the origins of various types of dances and masked characters that draw from both pre-Hispanic and Spanish traditions.

Cordry, Donald B. *Mexican Masks*. Austin: University of Texas Press, 1980.

When this book first came out, it was highly acclaimed as the most important reference guide that had ever been published on Mexican masks. However, as other scholars and collectors began following Cordry's leads they discovered that purported origins of some of the masks and information associated with them were highly questionable. This was particularly true for many of the masks from the state of Guerrero, where faking had become a thriving business by the 1970s. Bedridden in the latter part of his life, Cordry may not have been aware of this, since he had stopped conducting fieldwork and was purchasing masks from dealers. Although much of the information in the book is correct and many of the masks illustrated are good, readers are advised to use caution.

Duran, Fray Diego. *Book of the Gods and Rites and The Ancient Calendar*. Trans. and eds. Fernando Horcasitas and Doris Heyden. Norman: University of Oklahoma Press, 1971.

A document written in the sixteenth century by a Spanish priest who recorded information about the pre-Hispanic religious beliefs and practices of the Aztec peoples of central Mexico. This volume includes a breakdown of the Aztec calendar year, with descriptions of the different festivals. It also has black-and-white illustrations of the ceremonies, including a few showing priests wearing masks and impersonating the gods.

Esser, Janet Brody. *Faces of Fiesta: Mexican Masks in Context.* San Diego: San Diego University Press, 1981.

A catalogue for an exhibition on Mexican masks, with an essay by Esser discussing the cultural context in which the masks are used.

———. *Máscaras ceremoniales de los tarascos de la sierra de Michoacán.* Mexico: Instituto Nacional Indigenista, 1984

An in-depth study of the festival dances in the Tarascan villages in the highland region of Michoacán, with an emphasis on the types of costumes and masks worn by the performers.

———, ed. *Behind the Mask in Mexico.* Santa Fe: Museum of International Folk Art and Museum of New Mexico Press, 1988.

A scholarly book on Mexican masks, compiled and edited by Esser, that accompanied an exhibition at the Museum of International Folk Art. It contains twelve essays by scholars who address masked festivals in different geographical regions of Mexico. The last section of the book served as a catalogue for the exhibit.

Fiestas in Mexico: Complete Guide to Celebrations Throughout the Country. Mexico: El Ediciones Lara, S.A., 1978.

A good guidebook listing the major festivals that take place in each state of Mexico throughout the calendar year. Maps provide locations for most of the towns mentioned in the text.

Gibson, Charles. *The Aztecs Under Spanish Rule. A History of the Indians of the Valley of Mexico, 1519-1810.* Stanford: Stanford University Press, 1964.

A scholarly work in which Gibson analyzes the introduction of the European *cofradía* system and how it was eventually adopted into the Indian communal and ritual way of life. He also discusses the pre-Hispanic antecedents for this type of communal organization.

Griffith, James S., and Felipe Molina. *Old Men of the Fiesta: An Introduction to the Pascola Arts.* Phoenix: Heard Museum, 1980.

A catalogue for an exhibition of *Pascola* masks, with essays by two leading scholars on the Yaqui and Mayo peoples of Sonora and Sinaloa.

Harris, Max. "Moctezuma's Daughter: The Role of La Malinche in Mesoamerican Dance." *Journal of American Folklore* 109, 432 (1996): 149-177.

An excellent article on the female character *Malinche* and the various roles she plays in Mexican mythology and dance performances.

Kurath, Gertrude Prokosch. "Drama, Dance, and Music." In: *Handbook of Middle American Indians.* Vol. 6. Austin: University of Texas Press, 1967.

A very informative article by a noted scholar in the field of performance, dance, and music in Europe and Latin America. She discusses dance traditions of Mexico through an analysis of European and pre-Hispanic traditions and provides many good black-and-white photographs of the performers.

Lechuga, Dr. Ruth Deutsch. *Máscaras tradiciones de México.* Mexico: Banco Nacional de Obras y Servicios Públicos, S.N.C., 1991

A large format book, with one hundred and twenty of Lechuga's black-and-white and color photographs of Mexican masked dancers. The text provides a wealth of information about masked dances throughout Mexico, drawing from a lifetime of field research by Lechuga.

Lechuga, Ruth D., and Chloë Sayer. *Mask Arts of Mexico.* San Francisco: Chronicle Books, 1994.

A handsome book featuring color photographs of over a hundred Mexican masks from the collection of the Museo Ruth Lechuga de Arte Popular Mexicano. The text by Lechuga and Sayer is brief but informative.

Le terre et le paradis: masques mexicains. Bruxelles: Foundation Europalia International, 1993.

A catalogue from an exhibition in Charleroi, Belgium, that featured four hundred Mexican masks from the Museo Rafael Coronel in Zacatecas, Mexico. It is a good visual reference for older masks from diverse areas of Mexico, but some of the information in the captions is inaccurate.

Luna Parra de G. Sainz, Georgina, and Graciela Romandia de Cantu. *El Mundo de la Máscara.* México: Fomento Cultural Banamex, 1979.

A large-format book full of color photographs of masked dancers in various regions of Mexico. The illustrations also include individual masks, but many of these are strictly commercial pieces from the state of Guerrero.

Mayo Máscaras. Mexico: Gobierno del Estado de Sinaloa y DIFOCUR, n.d.

A small catalogue produced in the state of Sinaloa that discusses and illustrates the masking traditions of the Mayo people in this part of Mexico.

Mendez, Leopoldo, et al. *The Ephemeral and the Eternal in Mexican Folk Art.* 2 vols. Mexico: Fondo Editorial de la Plastica Mexicana, 1971.

One of the most important references for learning about the folk arts of Mexico. Volume two focuses on festivals and ceremonial life with close to seven hundred color illustrations, many of which show masked dances.

"Mexican Masks from the Southwest Museum Collection." *Masterkey* 62, 2 & 3 (1988).

A small but informative publication featuring a collection of sixty-six masks that were temporarily housed in the Southwest Museum in Los Angeles, California. Photographs of the masks are augmented by color photographs of masked dancers and mask makers.

Miller, Virginia E., Dudley M. Varner, and Betty A. Brown. "The Tusked Negrito Masks of Oaxaca." *The Masterkey* 49, 2 (1975): 44-50.

A short article that discusses the origins and roles of black-faced characters in festival performances of Oaxaca, with a focus on black masks with small tusks projecting from the sides of the mouths.

Mompradé, Electra L., and Tonatiúh Gutiérrez. *Historia General del Arte Mexicano.* Vol. 4. *Danzas y Bailes Populares.* México: Editorial Hermes, 1976.

Another important reference for learning about festivals and dances of Mexico, although some of the performances discussed are no longer carried out today. The book has over two hundred black-and-white photographs, as well as sketches, portraying the dancers, many of whom wear masks.

Moya Rubio, Victor José. *Máscaras: La Otra Cara de México.* Mexico: UNAM, 1978.

A large catalogue showing over two hundred Mexican masks from the collection of Victor José Moya, interspersed with photographs of masked dancers. Text about the dances, costumes, and masks was written by the collector, who spent a great deal of time in the field.

Oettinger, Marion Jr. *Dancing Faces. Mexican Masks in a Cultural Context.* Washington, D.C.: Meridian House International, 1985.

A small publication that accompanied an exhibition of Mexican masks in Washington, D.C. A series of short essays by Oettinger discuss the making and use of the masks within their cultural setting. The masks from the exhibit are not illustrated in this book, but there are photographs showing makers and masked dancers.

Ogazón, Estela. *Máscaras.* Mexico: Universidad Nacional Autonoma de Mexico, 1981.

Estela Ogazón and her husband, Jaled Muyaes, have traveled extensively through Mexico observing masked dances first-hand and collecting masks from makers and performers. Today they own over a thousand Mexican masks, and their knowledge of the various dances performed and styles of masks worn over the past decades is quite impressive. This small catalogue from an exhibition in Mexico City illustrates a selection of their masks and provides some good but brief discussions of types of dances and identification of masks.

Olivera, Mercedes B. *Danzas y Fiestas de Chiapas.* México: FONDAN, 1974.

A useful publication on festivals and dances in the state of Chiapas, with detailed calendars, maps, and discussions as to the history, meaning, and descriptions of each dance. It is illustrated with black-and-white photographs of the performers, some of whom wear masks.

Rael, Juan B. *The Souces and Diffusion of the Mexican Shepherds' Plays.* Guadalajara: Liberia La Joyita, 1965.

A good reference for learning about the European history of the *Pastorela* drama and how it is interpreted in many regions of Mexico today.

Ravicz, Marilyn Ekdahl. *Early Colonial Religious Drama in Mexico; from Tzompantli to Golgotha.* Washington, D.C.: Catholic University of American Press, 1970.

An excellent study of the types of plays and dances being performed in Mexico at the time of the Spanish occupation of this region and the subsequent introduction of European-style dramas and dance performances in the early colonial period. Her information is primarily drawn from the colonial chronicles, which are carefully referenced throughout her discussions.

Redfield, Robert. *Tepoztlán: A Mexican Village.* Chicago: University of Chicago Press, 1930.

A classic ethnographic study of the Nahua community of Tepoztlán, in the state of Morelos, in central Mexico. Redfield discusses the organization of the community *barrios*

and their relationship to the pre-Hispanic *calpulli* system and how this is carried over into their fiesta cycle. He also describes the carnival celebration of Tepoztlán with the *Chinelo* performers.

Reina, Ruben E. "Annual Cycle and Fiesta Cycle." *Handbook of Middle American Indians.* Vol. 6. Austin: University of Texas Press, 1967.

A good overview of the fiesta cycle as it existed in the mid-twentieth century among different cultural regions of Guatemala and Mexico. Reina ties this to the agricultural cycle and explains why the festivals differ from one region to another.

Sahagún, Fray Bernardino de. *Florentine Codex: General History of Things of New Spain.* 13 vols. Trans. and eds. Charles E. Dibble and Arthur J. O. Anderson. Santa Fe: School of American Research and the University of Utah.

An important colonial chronicle documenting the pre-Hispanic beliefs and practices of the Indian people living in central Mexico in the early sixteenth century. Book two provides a calendar and descriptions of the festivals and ceremonies that took place throughout the Aztec agricultural year.

Sánchez Flores, Francisco. *Danzas Fundamentales de Jalisco.* México: FONDAN, 1975.

A small publication focusing on six different types of dances found in the state of Jalisco, including the masked performances of the *Paixtlis* and the *Tastoanes.*

Sánchez García, Julio. *Calendario folklórico de fiestas en la República Mexicana.* Mexico: Editorial Porrúa, S.A., 1956.

A calendar of fiestas presented month by month, with states listed in alphabetical order. This is a good general guide but many important towns and festivals are not mentioned.

Santoscoy, Alberto. *La Fiesta de Los Tastoanes: Estudio Etnológico Histórico.* Guadalajara: Tipografía del Gobierno, 1889.

An early study of the *Tastoanes* dances in Jalisco with an interesting discussion of their possible origins.

Sepúlveda, María Teresa. *Catalogo de Máscaras de Estado de Guerrero de las Colecciones del Museo Nacional de Antropología.* Mexico: INAH, 1982.

An extensive catalogue illustrating over two hundred masks from the state of Guerrero in the collection of the Museo Nacional de Antropoligia in Mexico City. Each mask has information about its provenience, linguistic group, materials used, the dance, and character portrayed. Masks made strictly for decorative purposes are also shown and labeled as such.

Toor, Frances. *A Treasury of Mexican Folkways.* New York: Crown Publishers, 1947.

A good reference on the folk life of Mexico, with a substantial part of the book devoted to fiestas and the role they play within the communities. This includes some descriptions of masked dances.

Vazquez Santana, Higinio, y J. Ignacio Davila Garibi. *El Carnaval.* México: Talleres Gráficos de la Nación, 1931.

This small book provides a good overview to the variety of carnival celebrations that took place throughout Mexico in the early twentieth century, including black-and-white photographs of masked performers.

Warman Gryj, Arturo. *La Danza de Moros y Cristianos.* Mexico: Sep/Setentas, 1972.

An important reference for learning about the emergence of the Moor and Christian dance drama in Spain and its spread to the New World. The book includes some photographs of the drama in different parts of Mexico.

Williams García, Roberto. *Fiestas de las Santa Cruz en Zitlala.* México: FONDAN, 1976.

A brief but interesting description of the Holy Cross feast day celebrations in Zitlala, Guerrero. It includes many photographs of masqueraders participating in the events.

Winningham, Geoff, et al. *In the Eye of the Sun: Mexican Fiestas.* New York: W. W. Norton & Company, Inc., 1997.

A recent publication featuring beautiful color photographs of Mexican fiestas, some of which include masked dancers.